Chagall

Love and the Stage
1914–1922

Royal Academy of Arts, London
2 July – 4 October 1998

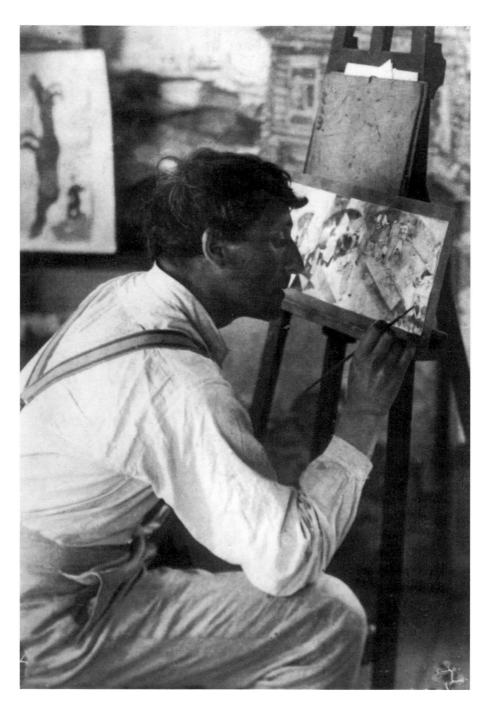

Chagall painting a study for *Introduction to the Jewish Theatre*, November 1920

Chagall

Love and the Stage 1914–1922

Edited by Susan Compton

ROYAL ACADEMY OF ARTS, LONDON
IN ASSOCIATION WITH

MERRELL HOLBERTON
PUBLISHERS LONDON

First published on the occasion of the exhibition
'Chagall: Love and the Stage 1914–1922'
Royal Academy of Arts, London, 2 July – 4 October 1998

The exhibition was organised by the Royal Academy of Arts, London

Supported by the Exhibition Patrons Group

Guest Curator: Susan Compton
Royal Academy Curators: Norman Rosenthal, Simonetta Fraquelli
Exhibition Organiser: Susan Thompson
Exhibition Assistant: Harriet James
Editorial Coordinator: Sophie Lawrence
Photographic and Copyright Coordinator: Miranda Bennion
Assistant Photographic Coordinator: Roberta Stansfield

Essay by Didier Schulmann translated from the French by Caroline Beamish
Map by ML Design

The Royal Academy of Arts is grateful to Her Majesty's Government for its
help in agreeing to indemnify the exhibition under the National Heritage
Act 1980, and to the Museums and Galleries Commission for their help in
arranging this indemnity.

British Library Cataloguing-in-Publication Data
A catalogue record for this book is available from the British Library

ISBN: 0 900946 62 8 (Royal Academy paperback)
ISBN: 1 85894 058 3 (hardback)

Copyright © 1998 Royal Academy of Arts, London

First published by
Merrell Holberton Publishers
Willcox House
42 Southwark Street
London SE1 1UN

Designed by Kate Stephens
Produced by Merrell Holberton Publishers
Printed and bound in Italy

Cover illustrations
Front: Marc Chagall, *Lovers in Pink*, detail (cat. 17)
Back: Marc Chagall, *Dance* (cat. 33)
Frontispiece: Marc Chagall painting a study for
Introduction to the Jewish Theatre, November 1920

All works of art are reproduced by kind permission of the owners.
Specific acknowledgements are as follows:

Amsterdam, Stedelijk Museum, fig. 2
Berne, photo courtesy of the Kunstmuseum, fig. 6, 9
Joachim Blauel – Artothek, cat. 1
Boston, photo courtesy of Museum of Fine Arts, Boston, fig. 5
Budapest, photo courtesy of Szépmüvészeti Museum, fig. 12
Carpentras, photo courtesy of Bibliothèque Inguimbertine,
Archives et Musées de Carpentras, fig. 11
Eindhoven, photo courtesy of Stedelijk Van Abbe Museum/
photo by Peter Cox, fig. 10
Fabrice Gousset, cat. 40, 42, 45, 46, 48, 50
Hanover, photo courtesy of Sprengel Museum, Hanover, fig. 26
Jerusalem, photo © The Israel Museum, fig. 23, 24
London, photo courtesy of The Conway Library,
Courtauld Institute of Art, fig. 21
London, © Tate Gallery, cat. 12
New York, © 1987 The Metropolitan Museum of Art, cat. 6
New York, © 1998 The Museum of Modern Art, cat. 13
Paris, Archives Ida Chagall, frontispiece
Paris, © Centre G. Pompidou, fig. 1/photos by Philippe Migeat, cat. 26, 43, 44,
49, 52, 53, 54, 55, 56, 57, 58, 59
Paris, photo courtesy of Centre G. Pompidou, fig. 7
Philadelphia, photo courtesy Philadelphia Museum of Art, fig. 27
Tel Aviv, photo courtesy The Tel Aviv Museum of Art, fig 25, 26

Contents

Lenders to the Exhibition

Tate Gallery, London

State Tretiakov Gallery, Moscow

The Metropolitan Museum of Art, New York

The Museum of Modern Art, New York

Musée national d'art moderne, Centre Georges Pompidou, Paris

The State Russian Museum, St Petersburg

and all other lenders who wish to
remain anonymous

Acknowledgements

The organisers of the exhibition are particularly indebted
to Meret, Bella and Piet Meyer, for without their support
and generosity it would not have been possible to realise
the exhibition. In addition they would also like to thank
the following people who have contributed to the
preparation of this exhibition and the catalogue in
many ways:

Ida Balboul
Michael Compton
Tatiana Goubanova
Vladimir Gusev
Agnes Husslein
Joseph Kiblitsky
Daniel Marchesseau
Evgenia Petrova
Didier Schulmann
Michel Strauss
Carla Schulz-Hoffmann
Nicholas Serota
Werner Spies
Kirk Varnedoe

President's Foreword

THE ROYAL ACADEMY OF ARTS is proud to present another exhibition devoted to the work of Marc Chagall, one of the key artists of this century and one of our past Honorary Academicians. A little over a year ago the opportunity arose to complement the retrospective that we hosted in 1985, when our Exhibitions Secretary, Norman Rosenthal, was shown by the Director of the Tretiakov Gallery in Moscow, Valentin Rodionov, some of the most original and exciting work that Chagall ever created – the murals he painted in 1920 for the Jewish Chamber Theatre. The Academy was delighted when it was proposed that they should be shown here in London and the Sackler Wing provides the ideal setting for visitors to see the work in a similar space to the one for which the artist had originally painted it.

It was a splendid opportunity to present to the British public the monumental 'Introduction to the New Theatre', as Chagall liked to call it, with its related panels. We invited Dr Susan Compton, the curator of our successful retrospective, to return to select further work that Chagall painted in the productive years he spent in Russia from 1914 to 1922. We are most grateful to all those who have enabled us to show wonderful work which was not available for loan to the Academy in 1985. The paintings shown here have been generously lent by private collectors in Moscow, St Petersburg and the West, as well as by museums in Russia, Paris, New York, Munich and London. Our thanks must go especially to the Russian Museum in St Petersburg, lender of some of Chagall's most striking work, which, together with paintings from the Tretiakov Gallery itself, form the nucleus of this exhibition.

The exhibition is enhanced by the publication of this book which will provide visitors with a record of what they have seen as well as giving an authoritative background to these Russian years.

Sir Philip Dowson, CBE
President, Royal Academy of Arts

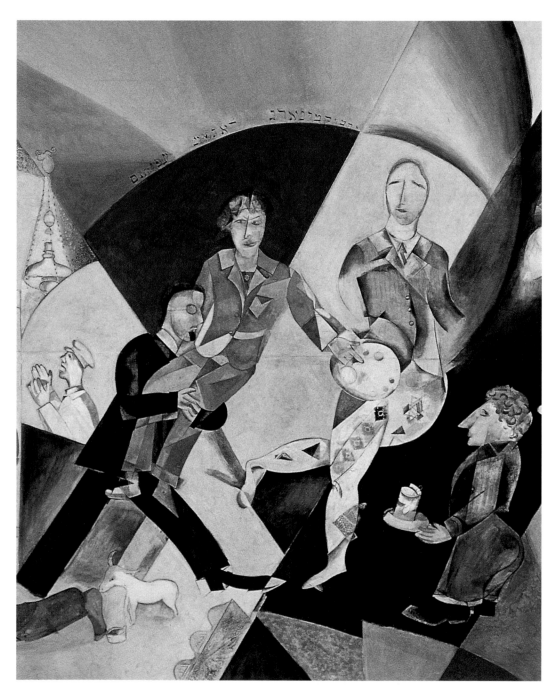

Detail from *Introduction to the Jewish Theatre* (cat. 31), showing the artistic director, Abram Efros, presenting Chagall to the director, Aleksei Granovsky

Introduction

Susan Compton

MARC CHAGALL was a man of passion, a man of fierce loves. Foremost was his love of art, the key which unlocked a world wider than the one into which he was born. Finding that he had artistic talent, he could not wait to leave his home town and his family; he was drawn by the hope of success to the wider culture of St Petersburg and from there to Paris, the mecca for avantgarde artists in the first decades of this century. When at the age of twenty-seven Chagall returned to Vitebsk – to his family and his fiancée – he had already been transformed by fame though not yet by fortune.

In the eight years which followed Chagall felt able to acknowledge the genuine love he had retained for his upbringing. He rediscovered his affection for his close-knit family, for his mother and father and his numerous brothers and sisters; he fulfilled his love for his fiancée, taking her for wife, helpmeet and inspiration; and he affirmed his love for his culture, which he adopted as the exotic inspiration for his art (much as Paul Gauguin had adopted the South Seas). These reawakened loves inspired his painting with a realism that he had put aside in Paris, where, in the crowded studios of La Ruche, he had lived a bohemian life fuelled by the intellectual stimulation of fellow students, who, like himself, were pushing aside the limits of art as they had learnt it. In Paris he tasted a cultural freedom that was denied him as a Jew in pre-Revolutionary Russia. But on his return to the comparatively restrictive life of Vitebsk Chagall began to revel in its distinct architecture, its churches and synagogues, its streets of wooden houses; he looked afresh at everyday objects, the clocks and mirrors of the bourgeois surroundings that he had once spurned. He adopted more naturalistic colours and noticed the idiosyncracies of the faces round him. Yet he did not sentimentalise or particularise, he observed and often generalised, attempting to discern and define the deeper layers of life. His love was seasoned with poetic wit; it was no mawkish sentimentality that caused him to place a violinist up a tree or to allow a head to detach itself from its body, but his concern to convey the special essence of his culture that was steeped in folk legend rather than philosophy. The resulting pictures formed the core of Chagall's art for the remainder of his life, even though most remained in Russia and he did not see them after he left his homeland in 1922 until his brief visit to Moscow and Leningrad in 1973. Yet the loves they embody and the way he expressed them continued to inspire him.

The climax of his work in Russia – and the pivot of this exhibition – was the huge canvases that he painted at the end of 1920 to decorate the auditorium of a new Jewish theatre in Moscow. In them Chagall set forward a programme, not simply establishing an ethnic theatre form for a director and his band of actors, but embodying a whole way of life that had been hidden from the majority of inhabitants of Russia. No wonder the artist was determined that his mural decorations should not merely entertain a theatre audience but be available to the general public who would view them as contemporary works of art, as monuments to a valid artistic endeavour. The murals were, of course, political. They celebrated the new-found citizenship of Jews, for so long persecuted and restricted and denied the right to their own theatre. Yiddish theatre turned out to be such a popular art form that larger premises were required, and by 1925 the murals were in the foyer of the new building.

Not surprisingly, the paintings later incurred hostility, when ethnicity was seen to challenge monolithic Stalinist culture. Hostility began even before 1949 and the formal dissolution of the Jewish Theatre: the murals had been taken down in 1937 during the Purges when they were hidden under the stage; they were finally removed to storage at the Tretiakov Gallery in 1950. In 1966 a very small group of employees there, including the Director, secretly unrolled and spread out the murals, which were then rolled on to special, large drums to help preserve them. On the occasion of Chagall's visit in June 1973 great secrecy was again observed at the Gallery, with KGB agents present; only one member of the Press was allowed in, a correspondent of *Paris-Match*. Anti-Semitism was still the official policy. According to Gregory Veitsman, then Assistant Director of Technical Services, the Minister for Culture, Madame Furtsova, begged Chagall not to say anything against the Soviet Union and the Communist Government. Several years later the artist recalled that day and asked, '"And why were they so certain that there was anything bad to say about them?" After a brief pause he continued, "Of course, they destroyed such a rich, beautiful Jewish culture."' Fortunately the evidence of Chagall's championing his culture has survived to be restored and exhibited; today his paintings invite our engagement with his loves as he portrayed them, both on and off the stage.

Painting as Theatre, or Theatre as Painting?

Didier Schulmann

ONE OF THE MOST FASCINATING of the dozens of anecdotes about Marc Chagall is told by Abram Efros in his description of a first night at the Jewish Theatre in Moscow.[1] The story tells us more about the artist's relationship with painting, perhaps, than about his relationship with the theatre, although the two (as will be seen) often amounted to one and the same thing: '...just before Mikhoels went on stage he seized the actor by the shoulder and lunged at him frenziedly with his paintbrush as if he were a puppet, painting splodges on his costume and drawing birds and pigs on his cap so tiny that they would have been invisible from the auditorium even with binoculars ...'. This was carried out while the actors were waiting to go on and the audience growing restless. Mikhoels tried to break away from the artist's grip. Efros informs us that 'Chagall wept and muttered under his breath when we extracted the actor by force and pushed him on to the stage.' The artist's semi-hysterical state was certainly due in part to the imminent rise of the curtain, but it also reveals the extraordinary symbiosis between Chagall's pictorial and his imaginary worlds; the source of his inspiration was an imaginary stage complete with his own language (Yiddish), characters, speeches and scenery. Should we infer from Efros's anecdote that Solomon Mikhoels, 'touched up' at the last minute by Chagall, is a character from a painting by Chagall whose immediate threat to give his creator the slip and escape from the painting provokes one last intervention with the paintbrush before he is allowed to break free? Or, alternatively, is the flesh-and-blood actor remodelled by the painter so that, bearing the artist's final touches, he can present himself on stage as a character from that particular painting? Béatrice Picon-Vallin, the great specialist on Yiddish theatre,[2] explains the confusion in Chagall's mind between painting and the theatre with great insight:[3] 'It was as if Chagall wished to fit the theatre into a canvas, and the actors into the life of his pictorial universe: Chagall, who as soon as the seats were laid out in rows in the empty auditorium would start worrying about the audience ruining his work, who wanted to direct all the stage business himself and who, constantly fighting against the physical reality of the actors, cried out while he was applying Mikhoel's make-up: "If only I could tear out your right eye, what a mask I would create for you!"'[4] Theatrical fantasies began appearing in Chagall's painting well before his collaboration with the Jewish Theatre began. So what was it about? Were these his memories of real-life events? Of tales he had heard and translated into images? Of things he had read and imagined scene by scene?

Although not all Chagall's output need be submitted to this interpretation, there are one or two paintings that can usefully be examined in such a way. *The Dead Man* (fig. 1) is a painting said to represent a street,[5] but which in fact represents a highway; the highway consists of a broad dark triangle of which the base forms the lower edge of the painting and of which the apex, the vanishing point of the picture, is in the exact centre of the upper third of the painting. On either side of the road can be seen: small Russian houses; five figures, including from left to right, a fiddler straddled over the ridge of a rooftop, a dead man lying on the ground surrounded by candlesticks, a road sweeper sweeping the road, a woman with her arms raised to the sky, and the legs and lower back of a figure who seems to be running off between two houses. The scene is self-evidently theatrical, and its symbolism has already been variously interpreted;[6] one detail in the scene – the two falling flower pots – is connected (for reasons unknown) with the escape of the running man. What building material, apart from the pasteboard that stage sets are made of, is so feeble that a glancing blow could dislodge the flower pots on a window sill? Benjamin Harshav is of the opinion[7] that *The Dead Man* is a free interpretation of a play by Leonid Andreev, *The Life of Man*, staged by Vsevolod Meyerhold in 1907; according to Harshav, Chagall's paintings *Wedding* and *Birth* are also derived from stage pieces.[8] Whether their sources are literary or are based on something seen, both compositions place characters in their setting as if they were taken from a moment in a stage play.

Theatre is first and foremost text, and Chagall's art is the Yiddish language expressed in painting. It represents endless variations on his mother tongue: Yiddish catchphrases, Yiddish wordplay, Yiddish proverbs, Yiddish playlets and Yiddish songs all taken from religious texts and the customs and traditions of the closed Jewish communities in which the Russian Jews led their lives. In *To Russia, Donkeys and Others*,[9] of which the black background emphasises its connection with the theatre, the cow in flight over the roof (*a ku iz gefloygn ubern dakh*) refers to a story that has neither head nor tail; the decapitated cow is the embodiment of the kind of person who, carried away by his imagination, is said to have his head in the clouds. Chagall was aware of the way his linguistic inspiration could puzzle others: 'Here at the Louvre ... I came to realise why my alliance with Russia and Russian art never really developed. Because my language itself was foreign to them'.[11]

Chagall's involvement with the theatre was neither simply circumstantial nor limited only to collaborating when invited to do

so. Some of the features that are intrinsic to the theatre are also intrinsic to the art of Chagall: control of space (for the theatre), control of his subject on the painted surface (for Chagall); the location of the utterance of the texts (for the theatre), a place where language is made flesh and must remain permanently embodied (for the painting of Chagall).

Notes

1. Abram Efros, 'Les artistes du Théâtre de Granovski', *Iskusstvo*, May 1928, pp. 155–60; French translation published in *Marc Chagall: Les années russes - 1907–1922*, exh. cat., Musée d'art moderne de la Ville de Paris, 1995, pp. 248–51.

2. Author of 'Le théâtre Juif Soviètique pendant les années vingt', Lausanne, 1973.

3. See Béatrice Picon-Vallin, 'Marc Chagall et les débuts du GOSET', in Paris 1995, pp. 191–93.

4. J. Schein, *About the Moscow Jewish Theatre* (in Yiddish), Paris, chapter entitled 'Sholem Aleichem Evening'.

5. *The Dead Man* (*Le mort*) 1908, oil on canvas, 69 x 87 cm, Musée national d'art moderne, Centre Georges Pompidou, Paris.

6. See in particular: Franz Meyer, *Marc Chagall, Life and Work*, transl. R. Allen, New York n.d. [1960] pp. 66–67 and Benjamin Harshav, 'Le mort', in Paris 1995, pp. 32–35.

7. In the article cited in the previous note.

8. *Wedding* (*La Noce*, or *Le Mariage*) 1911, oil on canvas, 99.5 x 188.5 cm, Musée national d'art moderne, Paris; *Birth* (*La Naissance*) 1911, oil on canvas, 113.3 x 195.3 cm, The Art Institute of Chicago, gift of Mr and Mrs Maurice E. Culberg.

9. *To Russia, Donkeys and Others* (*A la Russie, aux –nes et aux autres*) 1911–12, oil on canvas, 157 x 122 cm, Musée national d'art moderne, Centre Georges Pompidou, Paris.

10. Marc Chagall, *Ma Vie*, p. 142.

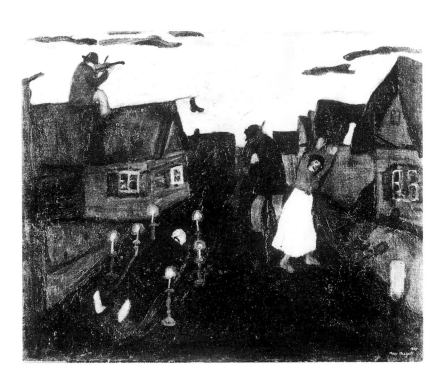

1. Marc Chagall, *The Dead Man*, 1908
Musée national d'art moderne, Paris

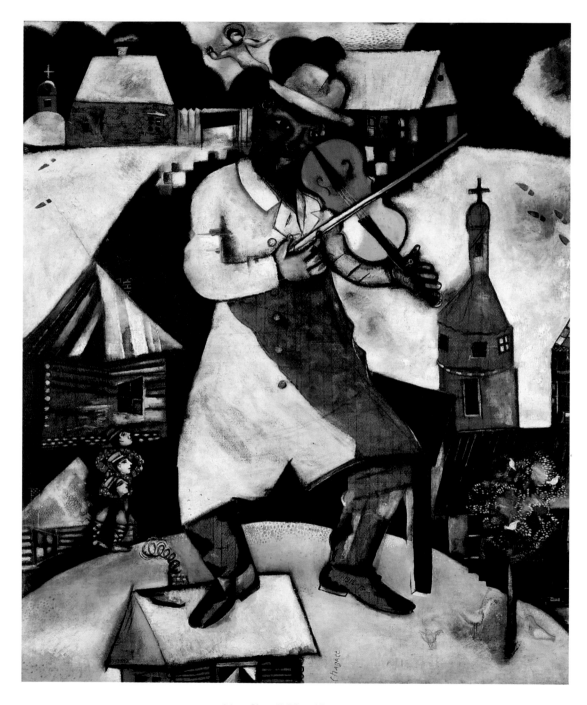

2. Marc Chagall, *The Fiddler*, 1912–13,
Stedelijk Museum, Amsterdam, on loan from: Netherlands Institute for Cultural Heritage

Marc Chagall: Love and the Stage

Susan Compton

CHAGALL PRESENTS US IN HIS PAINTINGS with an unfamiliar but fascinating life in which he often defies the laws of gravity, lifting his viewers into a kind of heaven on earth which he combines with the basest details of human existence. His art will always provoke strong reactions of admiration or criticism, for, frequently against fashion, he preserves a dramatic tradition with the message, 'All the world's a stage'.[1] Chagall's message emerged fully during the eight years that he spent in Russia (from 1914 to 1922) and found its apogee in his murals for the new State Jewish Chamber Theatre and in the large-scale paintings shown here, in which he often includes himself. Like a hero from the Yiddish literature which provided the plays for the new theatre, Chagall does not appear as an individual, concerned with inner reflections, but in the round, 'in his social relations, in his accustomed gestures … above all in his typical situations'.[2] His promotion of himself reached a climax in 1920 when he depicted himself prominently in the largest painting he had ever made, the huge mural entitled *Introduction to the Jewish Theatre* (cat. 31), where he is being held out by the critic Abram Efros as an 'offering' to the Theatre's director, Aleksei Granovsky.

It is hardly surprising that the nickname 'Chagall's Box' was quickly given to his transformation of a former domestic room in a Moscow apartment that had become the new auditorium for the State Jewish Chamber Theatre at the end of 1920. An audience of ninety people crowded into the rows of seats in front of a curtain decorated with a pair of goats' heads (cat. 29). When – on 1 January 1921 – that curtain first rose on the small stage built at the end of the room Chagall's wall decorations came to life; his painted world matched the world of speech where actors brought to life the faith and wit of their parents and grandparents in the words of a favourite Yiddish writer, Sholem Aleichem,[3] aided by sets and costumes likewise designed by Chagall (cat. 39–59).

Those Moscow audiences of cold and hungry people, living in a country bankrupted by the Civil War, were fortunate if they carried in memory the joy and squalor of life in the small towns in which they had grown up. Present troubles soon receded as the scenes unfolded before them in this, their own theatre. On the walls, Chagall's acrobatic dancers – carried off their feet by the fervour of the occasion – would bring a lump to the throat, while the painted musicians seemed to play old tunes that had enlivened many a family wedding. And, as viewers turned towards the windows, they could see the violinist himself, carried away by the bittersweet sounds coming from his instrument at the behest of the

master of ceremonies, who was also doing his best to encourage the old dancer to forget her years and show today's couple the way things should be done. When viewers looked back towards the exit the wedding couple themselves materialised – apparently from the wall itself – incongruously bringing their westernised ballet to this domain of Hasidic dancing. Even the ceiling (now lost) – entitled *The Flying Lovers* – was 'conceived as a sort of mirror in an interwoven pattern of grays, blacks and whites, suggesting a reflection of the colours and forms on all sides and beneath it.'[4]

Particularly in the mural *Love on the Stage* (cat. 30), with its avant-garde qualities, Chagall salutes the contemporary world where Jews could make their contribution to the new Soviet-Russian arts. It was a time when, according to one writer, 'All Russia is acting, some kind of elemental process is taking place where the living fabric of life is being transformed into the theatrical'.[5] At the same time, in his representations of traditional figures Chagall reminds his largely Hasidic audience of the special culture that had sustained their vitality in Russia as a people apart for nearly two centuries. His *Music, Dance, Drama* and above all *Literature* – a droll scribe writing the words 'Once upon a time' on his Torah scroll (cat. 32–35) – seem to match the religious enthusiasm and ecstasy that had been set on fire by the pious Rabbi Israel ben Eliever. This founder of Hasidism, a healer and miracle worker, was known as the Baal Shem Tov ('Master of the Good Name') because he and his disciples in the eighteenth century offered to Jews in Eastern Europe a new joy in earthly life through their teaching that 'Every Jew is an organ of the *Shekhinah*, or Divine Presence'. While the Yiddish-speaking audience at the Moscow Chamber Theatre, thanks in large measure to Chagall's decorations, saw a performance rooted in that optimistic tradition, the Zionists were watching their own productions at the Habima Theatre, where the actors spoke Hebrew and hoped to transfer their company to Palestine. Although much has been made of the difference between the two groups, both companies were housed in the same building in 1921.[6]

How did Chagall invent these images and how could his imagination transport his viewers into his world of fantasy? The answers are to be found within Chagall himself, in the driving force of his profound and lasting loves – above all, his love of his people and his cultural inheritance, which drove him to reinvent his art during the eight years he spent in Russia and resulted in this *tour de force*, his enormous canvases for the Auditorium of the Jewish Chamber Theatre, painted in less than two months!

The reproductions in this book show the extent of the changes in Chagall's art during the period 1914–22. The changes took place in part because of circumstances beyond his control – in particular the declaration of war in Europe in August 1914 and the Bolshevik takeover in October 1917. Chagall's world was turned upside down by the outbreak of world war, which found him in Russia, for in June 1914 he had intended to spend only a short time away from Paris, where – in the previous four years – he had transformed himself from a provincial Russian art student to a full member of the international avant-garde. The offer of a one-man exhibition in Berlin had given him the opportunity to go on to Russia for a brief visit home, to attend his sister's wedding and renew his relationship with his sweetheart, Bella Rosenfeld. But the war prevented Chagall from leaving Vitebsk where, at first, he felt trapped – all his recent oil paintings and drawings were at the Gallery Der Sturm in Berlin or in his studio at La Ruche in Paris and he had nothing to send to exhibitions in Moscow and St Petersburg in order to prove his status as an artist.

Nonetheless Chagall's reunion with his family provided him with fresh subject-matter, and his renewed love for Bella inspired strong emotions. The intensity of their relationship was reflected in his paintings, especially after the couple were married in July 1915 and he began to paint themselves as lovers. Chagall did not give up hope of returning to Western Europe (like Natalia Goncharova, who left Russia via Norway in 1915) but he failed to obtain official permission, so his exemption from military service expired. Fortunately, Bella's brother Jakov was in charge of the Office of War Economy in St Petersburg, so he found Chagall a sinecure post. In St Petersburg the financial circumstances of the couple greatly improved and they became part of a thriving artistic community: Chagall exhibited five times at the Dobychina Gallery there between 1915 and 1917 and contributed to avant-garde exhibitions in Moscow. Many of his patrons were Jews, anxious to found their own museum of modern Jewish art (see further Monica Bohm-Duchen's essay in this book). Chagall's work was increasingly noticed by influential critics and, after the Bolsheviks seized power in October 1917, there was talk of Chagall being responsible for art in the new Ministry of Culture. Bella dissuaded him from becoming embroiled in politics and the couple returned to Vitebsk. Chagall remained ambitious for official status and after the publication of a first illustrated monograph on his art in 1918 he was appointed Commissar for Arts in Vitebsk, with power to organise art schools, museums, lectures on art, and all other artistic ventures within the city and region.

The importance of this position may not easily be recognised today because Chagall enjoyed representing the little wooden houses on the edge, rather than the large buildings in the centre of Vitebsk, so most of his views of the town (cat. 2–4) fail to convey the size and prosperity of the city. Vitebsk was home to over sixty thousand people, with a proportion of rich and well educated Jewish families, among them Bella's. (The Rosenfelds were respected jewellers and Bella had graduated from a top girls' school and completed her studies in the Faculty of Letters at Moscow University; she had travelled in Europe with her mother.) The Rosenfelds' prosperity is reflected in some of Chagall's paintings of Bella with their little daughter, Ida, such as *Strawberries* (fig. 3) and *The Sick Child* (fig. 4). It was not convenient for Chagall to work in the Rosenfeld's home in the town centre where they were living in 1918, so he painted large pictures (such as *Promenade*, cat. 23) in the studio of his first art teacher, Yehuda Pen. As soon as he was made Commissar in September, Chagall organised street decorations for the anniversary of the October Revolution (two are reproduced here, cat. 27–28, *The Rider, War on Palaces*). He also founded a museum of new art and then a 'People's Art School' which opened in January 1919; he enticed artists from Petrograd (as St Petersburg was now renamed) to come and teach – his own early teacher, Mstislav Dobuzhinsky came and so did Ivan Puni (Jean Pougny), Puni's wife Xenia Boguslavskaia, and Robert Falk. None stayed very long and Chagall was soon replaced as principal by Vera Ermolaeva, who was sent from Petrograd to run the school because it was regarded as too right-wing. She invited Kazimir Malevich to join the staff and the arrival (in November 1919) of this strong personality, with views diametrically opposed to those of Chagall, made his position as a teacher there almost untenable.

Meanwhile, as well as his commitments as a teacher, Chagall was preoccupied by responsibility for theatre in the Vitebsk region. He gained experience with a new type of revolutionary satire which was pioneered to entertain and educate soldiers in the region. Chagall collaborated on nine productions and designed sets for two plays by Gogol intended for a theatre in Petrograd (see further Aleksandra Shatskikh's essay, p. 27). Thus, by the time he and Bella left Vitebsk for Moscow in May 1920, he had acquired a good deal of practical experience in the theatre, and when, in November, the critic Efros (joint author of a monograph on Chagall) suggested him to Granovsky as designer for the new Jewish Chamber Theatre, Chagall was eager to accept. The result was very significant, for his decoration for the auditorium and his set and costume designs influenced the way the first plays were performed.

The stage had provided some of the motivation for his art, which from the beginning was rooted in his equally profound love for art and for life. Chagall's natural gift of fertile invention enabled him to express his loves on paper and canvas more and more eloquently. The gift marked him as an original while he was still developing his technique at art school in St Petersburg (between 1907 and 1910), where his teachers at the Zvantseva School –

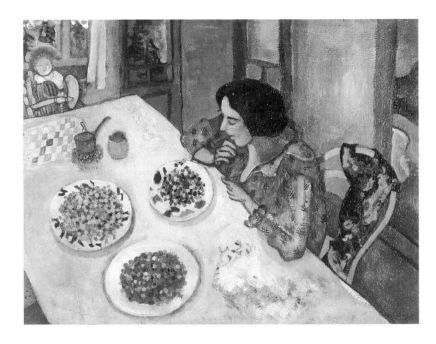

3. *Strawberries*, 1916, Private Collection

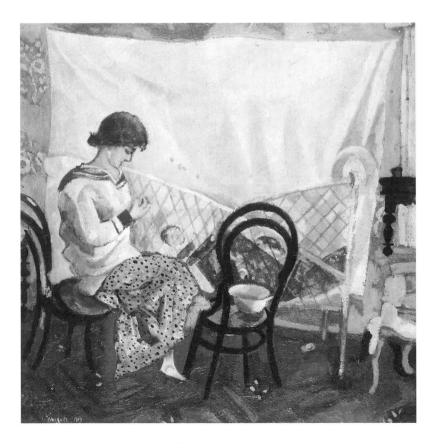

4. *The Sick Child*, 1919, Private Collection

Léon Bakst and Dobuzhinsky (whom Chagall lured to Vitebsk in 1919) – were both involved in designing for the stage.[7] Chagall never entirely forgot his teacher's exuberant approach to costume design; a close prototype for his *Dance* (cat. 33) is Bakst's costume for a Bacchante in *Narcisse* (fig. 7, p. 18).[8]

In Paris Chagall continued to observe pictorial ideas in the work of others and adapt what he needed to feed his own originality. He clothed his inventions in a variety of modern styles, reaching his maturity in paintings such as *The Fiddler* (fig. 2, p. 12) and *Russian Village from the Moon* (cat. 1). *The Fiddler* is the direct antecedent of *Music* in 'Chagall's Box' and elements of *Russian Village from the Moon* point towards the disc-like composition of *Introduction to the Jewish Theatre*. The two pictures painted at the end of his stay in the city include discrete vignettes and Chagall's final mastery of the empty space of his vast canvas depends on the exact placing of these glimpses of life, which only achieved their final form in the mural after he had made trials, such as *Composition with Circles and Goat* (cat. 37) and *Study for Introduction to the Jewish Theatre* (cat. 38).

But when Chagall returned to Vitebsk in 1914 he temporarily abandoned elaborate compositional strategies for a more straight-forward approach. The variety of viewpoints of *Russian Village from the Moon* and the complexity of its subject-matter were eclipsed – partly as a result, no doubt, of his visiting the large retrospective exhibition of paintings by Van Gogh in Berlin in June.[9] Some of Chagall's new pictures bear more than a chance resemblance to the work of Van Gogh, who also concentrated on subjects close at hand, such as street scenes in Arles and local characters. His paintings seem to have provided Chagall with the incentive to paint a series of views of his own town – among them *View from the Window, Vitebsk* (cat. 4) and *Street in Vitebsk* (cat. 2) – though the source is not so obvious because Chagall did not imitate Van Gogh's emphatic, rhythmic brushstrokes nor his intense colours. In his paintings of local people, like *The Village Idiot* (cat. 6), Chagall seems to have been moved by the Dutchman's abiding sympathy and love for real people which he saw in the early *Potato Eaters* (of 1885). For several months Chagall recorded Vitebsk and its inhabitants in pictures such as *Uncle's Store in Liozno* (cat. 3) and *The Barber's Shop* (cat. 5). When he began to paint larger pictures Van Gogh again provided a stimulus, for the stylisation of the hands in Chagall's *Jew in Red* (fig. 6) is very close to that of *Postman Joseph Roulin* (fig. 5) (which, like the *Potato Eaters*, was reproduced in the Berlin exhibition catalogue).[10] Chagall sent his new paintings to exhibitions in Petrograd and Moscow, and, in the long term, they provided him with the repertoire of factual observation that gave him the basis for imaginary pictures of his home town throughout the remainder of his life. Chagall told an interviewer in 1949:[11]

Man is like a tree, his roots lie in the earth of his country. Then the branches may spread out over the whole world. Of course, there are trees that hang in mid-air and others that stand in the water. But those that are rooted in solid ground bear the best fruit. Why do I always paint Vitebsk? With these pictures I create my own reality for myself, I recreate my home.

Chagall's fascination with Vitebsk encouraged him to transform the city into a mythical place. This is especially clear in the fanciful *Over Vitebsk* (cat. 13) with its tranquil view from the window of the room where Chagall was living in 1914–15, the city's colours disguised by snow. The unexpected element – to be found in all Chagall's studies and formal versions of this painting (including this one from about 1918) – is the old man with a sack on his back, who flies over the buildings. The figure suggests the eternal 'wandering Jew', who is identifiable in many of Chagall's later compositions as the Prophet Elijah (though here he also illustrates the Yiddish expression, 'he walks over the city', which was used to describe a beggar who goes from door to door). For this figure in the air which would become a central motif in Chagall's art, he may also have been inspired by a late nineteenth-century Russian popular folk print where two amazed passers-by watch a man flying out of the chimney (fig. 8, p. 18). If this is the case (and many of Chagall's Russian contemporaries deliberately based their paintings on such popular art) he has reclothed the figure and weighed him down so that he can move majestically and quizzically over the town. The floating figure is altogether irrational, encouraging the viewer to read the picture as a legend or folk tale.

Such an interpretation would have annoyed Chagall who was adamant that his painting was not literary. Chagall explained that in his art he 'searched for neither poetry nor literature nor for symbols. I only try to be myself. To be honest and simple.'[12] This may have been the painter's intention but the reality is not so clear: Chagall began to write as early as 1911, jotting down details of his childhood; he continued in 1915–16 in Petrograd, though he did not complete *My Life* until shortly before he left Russia for good in 1922. His marriage to Bella strengthened his literary ties, for Bella was a writer herself. She had contributed to the Moscow newspaper *Utro Rossii* while still a university student and her exceptionally vivid memories of episodes in her childhood (written in 1939) prove her literary talent.[13] Moreover, in Petrograd the couple came to know a number of poets, including Aleksandr Blok, Sergei Esenin, Boris Pasternak and the young Vladimir Mayakovsky. From then onwards the Chagalls always numbered more writers than artists among their friends.

Chagall was, however, pleased to acknowledge the mystical in his work:[14]

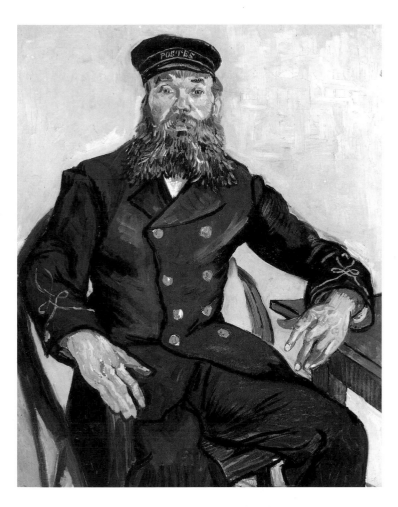

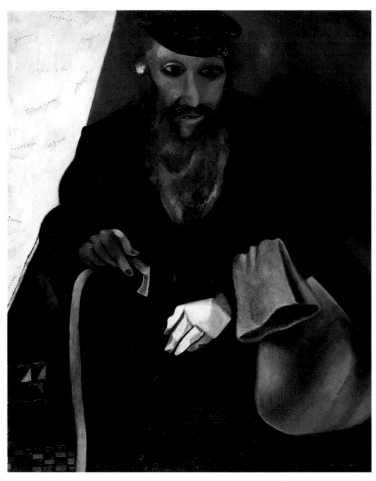

5. Vincent Van Gogh, *Postman Joseph Roulin*, 1888,
Gift of Robert Treat Paine 2nd, Courtesy Museum of Fine Arts, Boston

6. Marc Chagall, *The Jew in Red*, 1914, Private Collection

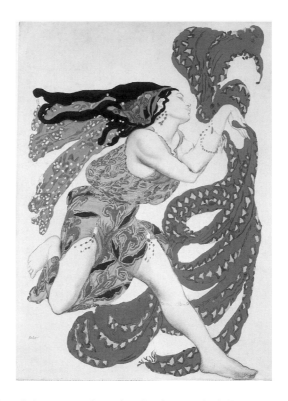

7. Léon Bakst, costume design for a Bacchante in the ballet *Narcisse*, 1910

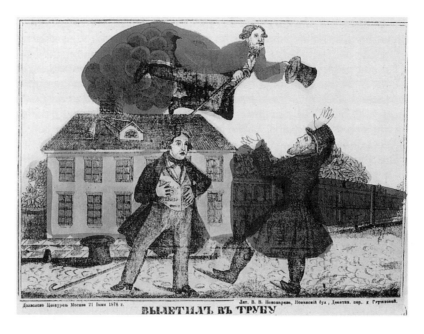

8. 'Look! He's flying out of the chimney!', Russian folk print, 1878

Some people wrongly fear the word 'mystical' and give it too orthodox, religious a colour. One must tear off the term's outlived, musty exterior and take it in its pure, lofty, sound form. Mysticism! ... How often this word has been hurled at my head, just as I was formerly accused of being 'literary'! But without mysticism would there be a single great social movement in the world? Every organism – be it individual or social – if it is deprived of the force of mysticism ... will it not wilt and die?

Yet Chagall's vision of the mystical in *Over Vitebsk* and other paintings may be misunderstood by a Westerner, who takes for granted a fundamental separation between profane and sacred in his world. But Chagall was brought up in a tradition founded by a man determined to overcome that separation. The Baal Shem Tov taught his followers: 'All that man possesses conceals sparks which belong to the root of his soul and wish to be elevated by him to their origin'. He added: 'Therefore one should have mercy on his tools and all his possessions; one should have mercy on the holy sparks.'[15] A twentieth-century interpreter of Hasidism, Martin Buber, writes (though not referring to Chagall's paintings): 'The profane is regarded only as a preliminary stage of the holy; it is the not-yet-hallowed "God dwells where one lets Him in."'[16] As Buber also points out, the Hasidic tradition resides in stories, not in formal teaching. Such stories were so much a part of Chagall's life that his memoirs strongly echo them and reading the pages of *My Life* enriches the meaning of many of his pictures. Sometimes his written fantasies sound like an offshoot of Sholem Aleichem's stories, especially the stories about Tevye the Dairyman, with his innocent naïveté in the face of fantastic events (better known in their adaptation as a musical, *The Fiddler on the Roof*). Chagall kept a special admiration for this author and may even have acknowledged his inspiration when he included himself with a drawing of *Over Vitebsk* in the frontispiece portrait for Sholem Aleichem's *The Great Fair, Scenes from my Childhood* (fig. 9).[17]

The more prosaic images of *The Clock* and its pendant *The Mirror* (cat. 10, 11) are still-lifes with psychological overtones in which Chagall uses everyday objects to characterise the claustrophobic state of mind of himself and his wife, who appear in the pictures as tiny inhabitants overwhelmed by the objects on the walls. In *The Clock* (which Chagall said hung on the wall at his parents' home) the artist looks wistfully through the window into the darkness outside, whereas Bella – head in hands – studiously avoids the light from the lamp reflected in *The Mirror*, of which the surface has darkened, as though her mental state has profaned the objects round her. On the other hand *The Mirror* may be Chagall's 'answer' to a painting with the same title by Goncharova, a member of the Moscow avant-garde, because he was never entirely oblivious to events in the world around him.[18] In his picture of himself and Bella entitled *Window in the Country* (cat. 9) he arranged their heads

in an impossible position that recalls two pictures by Dobuzhinsky, who had used the head of a woman perched on top of that of a man – looking like real people with severed heads – in a night–time view of a hairdresser's window. Dobuzhinsky was reacting to the abortive Revolution of 1905, and his pictures carried a veiled warning of the fate of the bourgeoisie.[19] On the other hand 1915 was early for Chagall to be worrying about revolution, and as *Window in the Country* was painted on his honeymoon perhaps he was reflecting on the revolution that marriage was making to his life and his art! Another honeymoon image is equally unexpected: entitled *The Poet reclining* (cat. 12), it shows Chagall lying on the ground, staring intently at something out of our sight. Curiously his pose is not unlike that of the hero in Poussin's painting *Echo and Narcissus* which belongs to the Louvre. The story of the mythical young man who fell in love with his own reflection was familiar to Chagall (for it was the subject of the ballet, *Narcisse*, that he had

9. Marc Chagall's frontispiece portrait for *The Great Fair: Scenes from my Childhood*, by Sholem Aleichem, edn. 1955

hoped to work on as a student). The artist has left us to imagine a pool in the foreground and where Poussin had painted his hero naked Chagall makes much of his own clothes, even giving his new jacket and hat a life of their own. When he began to express his relationship with Bella in pictures of lovers he continued to tease the viewer by making allusions to hidden meanings.

The first 'Lovers' painting is *Lovers in Green* (cat. 14), where Chagall portrays the lovers inside a circle within a square, a format which links the portrait to his *Homage to Apollinaire* (fig. 10). In that complex earlier composition, painted in Paris, the circle in the square surrounds a hermaphroditic figure resonating with

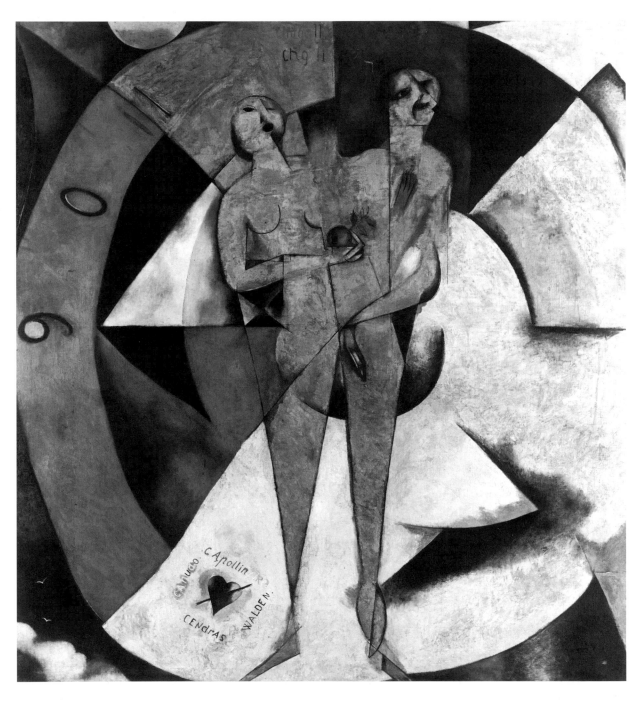

10. Marc Chagall, *Homage to Apollinaire*, 1911–12, Stedelijk Van Abbe Museum, Eindhoven

symbolism belonging to the earlier strand of Jewish mysticism, found in the medieval Kabbalistic book, *Zohar*. But the words that seem to describe the hermaphrodite, 'When is "one" said of a man? When he is male together with female and is highly sanctified and zealous for sanctification', can also apply to *Lovers in Green* as the *Zohar* continues with an eulogy to the union of man and wife.[20] So the profile heads of Chagall and Bella (with their bodies joined together and seen in full face) are bathed in mysterious light provided entirely by local colour; the style of their hats and clothes may integrate them into a particular historical time but the lovers enjoy a moment of eternity.

In contrast, Chagall places the monochromatic *Lovers in Blue* (cat. 15) firmly in the domain of the stage or carnival. Bella plays Columbine – the colour across her eyes doubling as a mask – while he plays Harlequin. In her eagerness, Columbine guides Harlequin's face towards her own and their lips form a single mouth. The more sensual *Pair of Lovers* (cat. 16) is the most erotic of the series but the wittily impossible position which the artist invents for their profiles removes any connection with today's brash expectations of a visualisation of physical love. The gentleness of *Lovers in Pink* (cat. 17) is reinforced by the eclipse of the artist's face; his presence is registered by his hands, curiously clinging like those of a child. Eyes and hands are key indicators for Chagall's lovers, who often appear blinded by their love, but in a second *Lovers in Green* (cat. 18) Bella's eye is fixed on something or someone else outside the picture, while the oblivious Chagall presses his head to her neck. His shorn head suggests the biblical story of Samson, who lost his strength when Delilah cut off his hair while he was sleeping.[21] Something of the changing role of Bella is implied by *Lovers in Grey* (cat. 19), which is the last of the series. In this version she becomes the dominant partner in a relationship where the single eye of each lover is wide open to the future, though apparently not fixed on the same goal.

These pictures are complemented by more programmatic pictures celebrating the love of Chagall and Bella. Bella's intense feeling of uplift while she still was engaged to Chagall is vividly expressed in her memoirs and in Chagall's painting of her visit on his birthday:[22]

I suddenly felt as if I were taking off. You too were poised on one leg, as if the little room could no longer contain you. You soar up to the ceiling. Your head turned down to mine and turned mine up to you, brushing against my ear and whispering something. I listened as your deep, soft voice sang to me, a song echoed in your eyes. Then together we floated up above the room with all its finery, and flew. Through the window a cloud and a patch of blue sky called to us. The brightly hung walls whirled around us. We flew over fields of flowers, shuttered houses, roofs, yards, churches.[23]

Bella's description of an overwhelming experience of love can also be applied to Chagall's *Over the Town* (cat. 21), painted when Chagall and Bella had been married for more than a year.[24] His affection often led him to play with observed forms, disordering them on a white surface in paintings such as this, where the giant and distorted bodies of the couple, carried away by their feelings, sail over tiny houses like some great Zeppelin with a freedom which rivals the use of geometricised shapes by some of Chagall's pioneering Russian contemporaries.

Chagall was not tempted to dispense altogether with the real world as Vasily Kandinsky or Malevich were. These artists deliberately attempted to portray what they described as a 'higher reality' by substituting abstracted elements for likenesses of the everyday world. Chagall had the opportunity to study their work in exhibitions[25] but he explained later, 'All post-Cubist artists substitute brain-activity for what should be in the heart. Anything constructed can easily be analysed by any brain'[26] and he chose to retain recognisable allusions to the world as we see it while allowing himself the freedom to distort or rearrange objects in his paintings; in this way his own 'higher reality' was firmly based in the real world. It may seem far fetched to allow Buber to elucidate his frame of mind but despite Chagall's comparatively sophisticated education the Hasidic background remains central to his work:[27]

The fact of creation means an ever renewed situation of choice. Hallowing is an event which commences in the depths of man, there where choosing, deciding, beginning takes place. The true hallowing of man is the hallowing of the human in him. Therefore the Biblical command, 'Holy men shall you be unto me' has received Hasidic interpretation thus: 'Humanly holy shall you be unto me.'

In *Over the Town*, the pair have, as it were, become one flesh for each has only one arm and their bodies are joined together, but in Jewish teaching marriage is God's greatest gift to humans and sexual relations an essential part of their life together, so there is nothing offensive in Chagall's display of their relationship. As well as raising their love as it were to 'heavenly' heights, Chagall keeps a human touch, creating a paradoxical mix of sublime and ridiculous – of holy and profane – for the transcendent lovers share their world with a tiny figure of the utmost earthiness relieving himself in the foreground!

Supreme among Chagall's tributes to his love for Bella is *Promenade* (cat. 23), where the artist controls the large space with dramatic skill, anticipating the scale he needed for work in the theatre. Chagall here introduces an element of caricature, exaggerating his own facial expression as though he were an actor; indeed, he holds a small bird, perhaps a reference to Maeterlinck's

play *The Blue Bird*, where the hero and heroine (two children) find their heart's desire not on their distant travels but when they return to their simple home. This reference to the play (which remained popular in the repertory of the Moscow Arts Theatre) could symbolise Bella's connection with Stanislavsky, whose lectures she had attended as a student, and her continuing ambition to become an actress.

Chagall used a quite different strategy for his *Wedding* (cat. 24), dating from the same year. Mira Friedman has noticed its uncanny resemblance to a French medieval painting, Nicolas Dipré's *Meeting of Joachim and Anna outside the Golden Gate* (fig. 11).[28] In this unusual subject (of which only the upper part survives) the embracing parents of the Virgin Mary, blessed by an angel, almost exactly correspond to the half-length couple in Chagall's *Wedding*. The figure bringing the heads of Joachim and Anna together visually transmits the idea that an angel was the intermediary that effected the conception of the Virgin Mary and Chagall, Friedman suggests, was aware of this because he drew the outline of a baby on the cheek of his bride, Bella, representing the child who was to be born to them. The French picture belongs to a museum in Carpentras, a city near Avignon where an ancient synagogue attracts many Jewish visitors. Chagall is unlikely to have travelled so far south during his first years in France when he was always short of funds so he may have acquired a postcard from a friend or even have found a reproduction in Vitebsk.

A black and white reproduction is also the likely source for the contemporary *Apparition* (cat. 25), which is close to an *Annunciation* by El Greco which Chagall could have seen in the Zuloaga Collection when he was in Paris. A second copy in the Szépmüvészeti Museum in Budapest (fig. 12) was reproduced in the Museum catalogues of 1913 and 1916 and may have been his source, although Chagall described *The Apparition* in his memoirs as based on a dream:[29]

Suddenly, the ceiling opens and a winged creature descends with great commotion, filling the room with movement and colors. A swish of wings fluttering. I think: an angel! I can't open my eyes; it's too bright, too luminous.

As a student Chagall had 'sent up' Christian imagery with his version of a Holy Family,[30] but now that he was involved in inventing new art for Jewish collectors he perversely appropriated Christian iconography and secularised it. So in *The Apparition* he replaces the Virgin Mary with a portrait of himself at his easel and he is the one to receive Gabriel's message, claiming inspiration as God's gift to himself. Such a subversion of traditional themes became a typical attitude of twentieth-century artists to the Christian heritage.[31]

Of course Chagall effectively hides his source for *The Apparition* by reducing his colours to blue, white and black, just as he had done for his *Marriage* by using only red, white and black. But he further disguises the source for *The Apparition* by inventing a Russian version of a Cubist style. He was not alone in adapting Cubism: the *Portrait of Anna Akhmatova* of 1915 (now in the Russian Museum, St Petersburg) by his fellow Jewish artist, Nathan Altman, is in a related style, but it shows more clearly its antecedents in the work of Fernand Léger, whose paintings both artists would have known when they were studying in Paris. By naming his picture *Apparition* Chagall found a pretext to loosen the structure and allow his cubist planes to become little more than a decoration – in the foreground they have turned into clouds to increase the vision of the heavenly breaking into his studio.

Chagall remained well aware of the work of his contemporaries. At the exhibition 'Contemporary Russian Painting' held at the close of 1916 at the Dobychina Gallery (where Chagall showed *Over the Town*) he seems to have noticed a 'panel' entitled *At the Seaside* by Aristarkh Lentulov, a fellow exhibitor.[32] In this picture Lentulov used real pieces of lace and beads glued on to the painted women's clothes where appropriate (no doubt as a way of introducing 'reality' into an avant-garde painting without replacing likeness by collaged planes as Picasso had done). Chagall subsequently developed his own way of using fabric, but instead of sticking it on to paper or canvas he dipped it into ink or paint and pressed it onto the surface, removing it to leave only its imprint. He used the technique in costume designs (cat. 53) and, on a large scale, in the mural *Love on the Stage*. But he also exploited the idea in black and white, particularly in pen-and-ink drawings, by using the weave of different cloths to produce interesting textures in *Abduction* (cat. 56), *With a Bucket* (cat. 58) and *Acrobat* (cat. 59).

Black and white was to play an increasingly important role in Chagall's artistic life in the following years, for commissions for book illustrations provided him with a regular income when he returned to Paris in 1923. In his final year in Russia he made a great many drawings, partly because he failed to gain any more commissions for stage design – his greatest disappointment being the rejection of the designs for *The Dybbuk* which the director of the Habima theatre had invited him to provide. Chagall had thought a great deal about the play during 1919 when its author, S. Ansky (Shloyme Rapaport, like himself from Vitebsk) had invited him to make designs for the play, and he was angry when Evgeny Vakhtangov gave the commission to Altman instead of himself.[33] For most of 1921 Chagall was living outside Moscow with Bella and Ida at a home for children orphaned in the civil war, to whom he taught painting, and it was no doubt impossible to concentrate on large canvases in those circumstances, even if paint

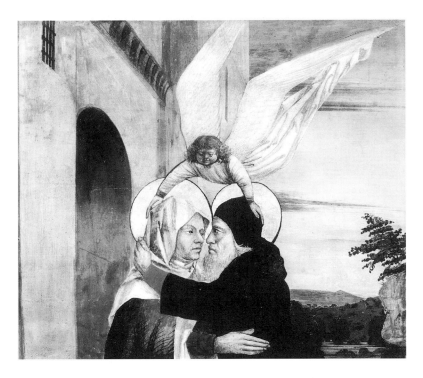

11. Nicolas Dipré, *The Meeting of Joachim and Anna outside the Golden Gate*, 1500, fragment of an altarpiece from the Cathedral in Carpentras

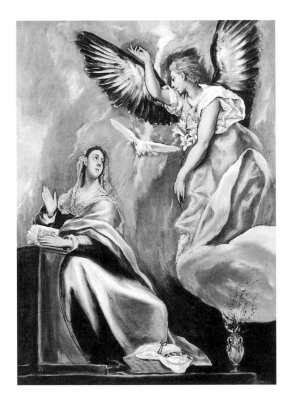

12. El Greco, *The Annunciation*, Szépmüvészeti Museum, Budapest

and canvas had been available. A contemporary photograph shows Chagall surrounded by the young boys who he describes with affection in the last pages of *My Life*:[34]

> *These children had been the most unhappy of orphans, all of them had been thrown out on the street, beaten by thugs, terrified by the flash of the dagger that cut their parents' throats. Deafened by the whistling of bullets and the crash of broken windowpanes, they still heard, ringing in their ears, the dying prayers of their father and mothers I loved them, they drew pictures. They flung themselves at colours like wild beasts at meat.... . I was entranced by their drawings, their inspired stammerings, and this lasted until the moment when I was obliged to give them up.*

This poignant description seems apt for Chagall himself: he, too, encountered the deprivation and, no doubt, the violence of life in the aftermath of the Civil War. In 1921 there must have seemed no future for him in Moscow, where younger avant-garde artists were busy debating the principles of Constructivism and turning increasingly to applied arts and design, while another faction was trying to reinstate the realism of the nineteenth-century Wanderers Group. Even when there was a partial return to a market economy after Lenin inaugurated his New Economic Policy in March[35] many intellectuals left for Berlin. Some time later that year the Chagalls returned to Moscow and Bella tried to go on the stage; unfortunately at a rehearsal she fell and was bedridden for some months. When Chagall finally obtained permission to leave for Berlin in April 1922[36] he was able to arrange for some of the most important paintings he had made in the previous eight years to be sent ahead by diplomatic bag to Kaunas in Lithuania. They included the pictures belonging to the Jewish collector Kagan Chabchai; Chagall took them first to Berlin (where Bella and Ida soon joined him) and then, a year later, to Paris, where he proceeded to copy them.[37] Thus he was able to begin a new life in Western Europe from the solid base of his recent work. Although the huge murals remained in Moscow, his stage designs for the Sholom Aleichem Evening were admired by audiences in Paris in 1927 when the Jewish Chamber Theatre travelled in Europe. On that occasion, Chagall sent back to Moscow a set of etchings he had made in France for Gogol's *Dead Souls* with the dedication, 'Given to the Tretiakov Gallery in witness of my entire love as a Russian artist for his homeland'. He was not able to return to Russia until 1973 when, as a French citizen, he had an emotional encounter at the Tretiakov Gallery with the mural paintings shown here. In 1987, two years after his death, an exhibition of his paintings from Russian museums and collections, with some paintings from France, was held at the Pushkin Museum, the Moscow home of French art. The message of Chagall's art remains true, for all the world's *his* stage, and the present exhibition pinpoints Russia – and Vitebsk – as the central point on his globe.

Notes

1 Shakespeare, *As You Like It*, 2: vii.

2 See Irving House, Eliezer Greenberg, *A Treasury of Yiddish Stories*, New York 1954, p. 33. The authors are describing Sholom Aleichem's writing, but the description is apt for Chagall's art.

3 Sholem Aleichem [real name Rabinovich] was born in Poltava in 1859, and died in the USA in 1916.

4 *Marc Chagall*, exh. cat. by James Johnson Sweeney, New York 1946, p. 46. Sweeney's is the earliest detailed account of the auditorium in the West, written when the artist was living in New York and after he had spent many hours renewing his friendship with the principal actor, Solomon Mikhoels, who stayed in New York in 1942 on a Russian cultural mission. Sweeney provides the most detailed description of the lost ceiling. See also here p. 33, Aleksandra Shatskikh note 5.

5 Viktor Shklovskii: *Zhizn iskusstva*, 4 April 1920, cited with no page reference by Konstantin Rudnitsky, *Russian and Soviet Theatre: Tradition and the Avant-Garde*, London, 1988, p. 41.

6 Habima (The stage) was founded in Moscow in 1917 and moved into Great Chernichevsky Street in April 1920; Granovsky's 'Melucha' (as the State Jewish Theatre was known in Yiddish) moved from Petrograd into another apartment in the same building on 20 November, 1920. See Shatskikh, p. 28.

7 Vsevolod Meyerhold's staging of Aleksandr Blok's *The Fairground Booth (Balaganchik)* and its influence on Chagall is discussed by Susan Compton in 'The Russian Background', *Chagall*, exh. cat., Royal Academy, London, Philadelphia Museum of Art, 1985, p. 32.

8 Chagall entered the Zvantseva School during the winter of 1908–09; Mstislav Dobuzhinsky designed Turgenev's *A Month in the Country* for Stanislavsky's Moscow Arts Theatre in 1909; Léon Bakst's designs for the ballet *Cléopâtre* were staged by Diaghilev's Ballet russes in Paris in summer 1909; his costumes for a Jewish and a Syrian dancer are among those reproduced in colour in *The Decorative Art of Léon Bakst*, London 1912 (reprinted Dover Publications 1972). For Diaghilev's 1909–10 season Bakst designed *Le Carneval* and *Shéhérazade*; *Narcisse* was presented in April 1911 at Monte Carlo. All Diaghilev's ballets were prepared and rehearsed in St Petersburg.

9 The exhibition of work by Van Gogh was held in Berlin at Paul Cassirer's Gallery in May–June 1914; Chagall's exhibition at Herwarth Walden's Gallery 'Der Sturm' opened at the beginning of June and he returned to Russia on 15 June.

10 Van Gogh's *Portrait of the Postman Roulin* (now in The Museum of Fine Arts, Boston; Robert Treat Paine II Collection) was listed as no. 117 in the catalogue; see D. Gordon, *Modern Art Exhibitions 1900–16*, Munich, Prestel, 1974, vol. 2, p. 303. Photographs suggest that Chagall's father resembled a Van Gogh character and Chagall may have noticed the resemblance; see *Marc Chagall, Les années russes 1907–1922*, exh. cat., Paris, Musée d'art moderne de la Ville de Paris, 1995, cat. 2, reproduced on p. 26.

11 J.P. Hodin, *The Dilemma of Being Modern: Essays on Art and Literature*, London, 1956, Chapter 4: 'Marc Chagall: In Search of the Primary Sources of Inspiration', p. 45. Hodin states that his interview with Chagall took place at Orgeval in 1949.

12 Hodin 1956, p. 44.

13 Bella Chagall, *Burning Lights*, transl. by Norbert Guterman, New York, 1946; this edition includes a brief biography on p. 7.

14 'Quelques impressions sur la peinture française', *Renaissance* nos. 2–3, 1945, pp. 54f. Chagall delivered the original in French at a conference at Holyoke College in 1943.

15 Quoted in Martin Buber, *Hasidism and Modern Man*, ed. and transl. by Maurice Friedman [1958], Atlantic Highlands, New Jersey 1988, pp. 24–25.

16 Buber 1988, p. 21.

17 Sholem Aleichem, *The Great Fair: Scenes from my Childhood*, transl. by Tamara Kahana, New York, 1955; the paperback edition of 1958 includes a drawing by Chagall on the cover.

18 Natalia Goncharova's *The Mirror* is reproduced as Plate 16 in Eli Eganburii (real name Ilia Zdanevich), *Natal'ia Goncharova, Mikhail Larionov*, Moscow, 1913, and also in the catalogue of her exhibition held in Moscow and St Petersburg in 1913.

19 Mstislav Dobuzhinskii, *Stekliannaia ulitsa v Vil'no*, 1906, is reproduced by Anna Povelikhina, Evgenii Kovtun, *Ruskaia zhivopisnaia vyveska i khudozhniki avangarda*, Leningrad, 1991, p. 63. His *Hairdresser's Window (Okno parikmakherskoi)*, 1906, is reproduced by Alla Gusarova, *Mstislav Dobuzhinskii, Zhivopis', Grafika, Teatr/Painting, Graphic Art, Stage Design*, Moscow, 1982, p. 68. Both watercolours belong to the State Tretiakov Gallery, Moscow.

20 *Zohar, The Book of Splendor*, ed. G.G. Scholem, New York, 1949.

21 See Judges 16:4–21.

22 *The Birthday* (Museum of Modern Art, New York) is reproduced on the cover of *Chagall*, London and Philadelphia, 1985. Chagall painted a second version in Paris in 1924; this was formerly in the Guggenheim Museum, New York.

23 Bella Chagall 1983, p. 228.

24 *Over the Town* is reproduced by V.P. Lapshin, *Khudozhestvennaia zhizn' Moskvy i Petrograda v 1917 goda*, Moscow, 1983, p. 27, as a work included in 'Contemporary Russian Painting'; this exhibition at N.E. Dobychina's gallery in Petrograd opened on 10 December 1916 so the usual date of 1917–18 is too late for this picture.

25 Chagall exhibited 24 pictures in 'The Year 1915' (April 1915, Gallery Mikhailova, Moscow), where Kandinsky showed *Composition No. 7, Improvisation No. 34*, and *Picture with White Lines* and *Picture with a Circle*. Nadezhda Dobychina exhibited Chagall's work in five exhibitions in 1916 and 1917 in her 'Bureau' in Petrograd, see Aleksandr Kamensky, *Chagall: The Russian Years 1907–1922*, London, 1989, p. 250. Dobychina had shown Malevich's first non-objective paintings at the exhibition 'Zero Ten' in her gallery in December 1915.

26 Hodin 1956, p. 44.

27 Buber 1988, p. 22–23.

28 Mira Friedman, 'Le Mariage de Chagall', *Revue de l'art*, no. 52, 1981, pp. 37–40.

29 Chagall, *My Life*, quoted in Franz Meyer, *Marc Chagall: Life and Work*, New York [1960], p. 255.

30 *The Holy Family*, 1910, Kunsthaus, Zurich; reproduced *Chagall* 1985, fig. 30, p. 159.

31 In Chagall's oeuvre the most extreme instance is his transformation of the Crucifixion in 1968–71, when he painted himself crucified in his *In Front of the Picture* 1968–71, Fondation Marguerite et Aimé Maeght, St-Paul-de-Venice.

32 Aristarkh Lentulov was organiser of the Knave of Diamonds exhibiting society; his *At the Seaside* is reproduced in *Sieben Moskauer Kunstler/Seven Moscow Artists 1910–1930*, Galerie Gmurzynska, Cologne, 1984, p. 191.

33 A costume design by Nathan Altman for *The Dybbuk* is reproduced in Rudnitsky 1988, p. 76, where the play is erroneously entitled *Hadibuk*. Vakhtangov's production of this play is described on pp. 53–54.

34 Chagall, *My Life*, quoted in Meyer 1960, p. 304.

35 See Susan Compton, *Russian Avant-Garde Books 1917–34*, London, 1992, for a description of these years.

36 His imminent departure was announced in *Ekran*, no. 30, 25 April 1922.

37 See Susan Compton, *Marc Chagall My Life – My Dream: Berlin and Paris 1922–1940*, Munich, 1990.

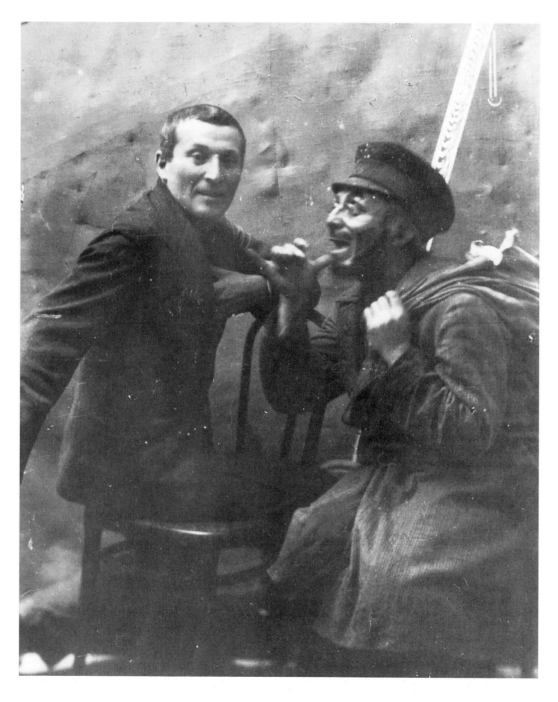

13. Chagall with the actor Solomon Mikhoels as Rabbi Alter in *Mazeltov*

Marc Chagall and the Theatre

Aleksandra Shatskikh

THE YOUNG PAINTER MARC CHAGALL came into contact with the theatre for the first time in St Petersburg in 1910, when he worked with his teacher Léon Bakst on a set for *Narcisse et Echo*, one of the ballets that would be performed by Diaghilev's Ballets Russes in France (see also fig. 7, p. 18). His encounter with Bakst shaped Chagall's understanding of the theatre almost inestimably. Bakst belonged to the *Mir Iskusstva* (World of Art) group, who demanded that the artist, as set designer, should also be central to the theatre performance.

Seven years later, in the renamed Petrograd, Chagall undertook his first independent work for the theatre, designing set and costumes for a programme at the 'Comedian's Halt' cabaret. The programme, directed by Nikolai Evreinov, consisted of three one-act plays. Chagall only designed the set for the last, *A Thoroughly Joyful Song*, and not, as is often reported, for *A Happy Death*. At the back of the stage hung an enlarged reproduction of his painting *The Drunkard* (1911). At Chagall's insistence the faces of the actors were painted green, their hands blue. In this way they became an eloquent part of the overall impression – one very much in keeping with the principles of his lyrical painting. In early 1919 the Petrograd Hermitage Theatre commissioned Chagall to design the sets and costumes for Gogol's *Marriage* and *The Card Players*. Though his designs were rejected, Gogol was to be a *leitmotiv* in Chagall's work over the next ten years, culminating in his illustrations for Gogol's *Dead Souls* in 1923–25. Chagall, not easily discouraged, went on to produce uncommissioned sketches for the costume and set design of a Stanislavsky Theatre production of *The Playboy of the Western World* by J.M. Synge. These designs, too, were rejected.

Much more important, however, than his few forays into the world of theatre in Moscow and Petrograd, where most of his designs were never realised, is Chagall's work as a designer in the theatre in Vitebsk, which underwent a veritable renaissance in the years immediately after the Revolution. Vitebsk was on the itinerary of professional theatre groups, which played the Municipal Theatre and the former Tichanovsky Theatre. There was a growing interest in amateur dramatics, too, the most important group staging its productions in the Studio Theatre of the Peretz Society. The Peretz Society group was noted for its frequent performances and for the breadth of its repertoire, which included plays by Sholem Aleichem, Sholem Ash, Karl Gutskov and local playwrights from Vitebsk. These professional and amateur groups still worked in the tradition of realist and psychological theatre, but in 1920 a new genre of theatre emerged in Vitebsk, the so called 'Theatre of Revolutionary Satire' or TEREVSAT, modelled on the 'agitprop' plays which had been performed for the Red Army troops since 1919. The first performance of the Vitebsk TEREVSAT was held on 7 February 1920, as part of the celebrations in honour of the 'Week of the Front'. In its wake theatres sprang up in several other parts of the Russian Republic, also naming themselves TEREVSAT, and the term is now synonymous with agitprop theatre.

The Vitebsk Theatre of Revolutionary Satire was the first in which Marc Chagall worked permanently. Producing one-act plays, satirical and humorous sketches or 'Tantomoresques', clowning and puppet shows, it bore many similarities to Russian folk theatre and the fairground. Rooted in the tradition of Russian folk humour, this theatre took as its material topical issues of the new state, basing its revues on press releases. It thus played a role similar to that of the satirical propaganda posters displayed in shop windows.

Chagall designed sets, costumes and masks for these agitprop plays. For *The Crossroads*, for example, he designed a set which was basically a parody of Viktor Vaznetsov's painting *The Legendary Heroes*. There were spaces in the set where the heroes' heads should have been, through which the actors stuck their own heads – a tableau with living figures. In the 'puppet shows', staged in the intervals, the actors enacted crudely painted puppets, concealed from the waist down behind a black curtain. The down-to-earth nature of the characters was emphasised by grotesquely exaggerated gestures and caricatural masks.

The Theatre of Revolutionary Satire went to Moscow at the end of April 1920, and Chagall, too, left Vitebsk for the capital one month later. In Autumn 1921 the theatre began rehearsing the play *Comrade Khlestakov*, an adaptation by D. Smolin of Gogol's *Inspector General*, transposed into the realm of the Soviet regime.[1] Chagall's sketches for the stage-set and costumes are dated 1920 and have been regarded as designs for a production of *The Inspector General* itself. However, a report in the Moscow journal *Ekran* makes it likely that the designs were really intended for the Smolin production.[2] The incorrect dating is due to Chagall himself, who appended dates to the sketches from memory considerably later.[3]

In one scene Chagall wanted to build two long panels for the stage, on one of which the old, provincial world was to be portrayed, literally, upside down. On the second panel the brave new world was to be illustrated with all its attributes – flags, slogans and banners. Times, however, were changing, and the play

was never even premiered. In May 1922, as Chagall left for Berlin, Vsevolod Meyerhold took over and transformed the theatre, rechristening it the 'Revolutionary Theatre of the Mossoviet'. It is interesting to note that, parallel to Chagall, Aleksandra Ekster was working on set and costumes for another production of *Comrade Khlestakov*. Her production fared better, and on 25 December 1921 was premiered at the State Theatre for Comedy and Drama in Moscow.

In parallel with his activity for the Theatre of Revolutionary Satire Chagall also began working for the State Jewish Chamber Theatre or GOSEKT (renamed GOSET in 1922), founded in 1919 in Petrograd. Like TEREVSAT it was a product of the Revolution and owed its development to Revolutionary cultural policy. It had set itself the task of becoming a genuine Jewish national theatre – not an easy one, since Jewish culture in Russia had only a limited theatrical tradition (see Monica Bohm-Duchen's essay, pp. 42–45), and consequently the little theatre struggled to establish a clear-cut artistic line.

Marc Chagall's first contact with the Jewish Theatre came in August 1919, when the group visited Vitebsk at the invitation of the Peretz Society. The theatre-going public of Vitebsk had the opportunity to see almost all of the group's productions: directed by R.A. Ungern, *Uriel Acosta* by Karl Gutskov; directed by Aleksei Granovsky (a student of Max Reinhardt), *Les Aveugles* by Maeterlink, *Ammon and Tomora* and *The Sin*, by Sholem Ash, and *Prologue* by Granovsky himself. Chagall, busy preparing for the coming academic year at the Academy of Art in Vitebsk, was certainly among the audience – not only because of his own interest but also because his wife Bella had ambitions to become an actress. Neither the performances, however, nor the set designs, by such artists and members of the World of Art group as Mstislav Dobuzhinsky and Granovsky himself in conjunction with P.N. Schildknecht, came up to the Chagalls' expectations. Three years later Chagall wrote, 'I saw those performances in the realistic style of Stanislavsky, and I could not conceal my disappointment.'[4] He did not meet any of the people then running the Jewish Theatre.

After its guest appearance in Vitebsk the Theatre returned to Petrograd, then on 20 November 1920 moved to Moscow, joining forces with the Hebrew-speaking Jewish State Theatre, known as the Habima, which had occupied a three-storey businessman's house in Great Chernichevsky Street in central Moscow since April 1920. The new arrivals were allocated rooms on the ground and first floors. The reception areas of the old house were made into an auditorium, and several internal walls demolished. The theatre seated a maximum of ninety. Granovsky was in charge; the leading actor was Solomon Mikhoels. The theatre began to develop its own style, placing special emphasis on the individual form of expression of the actors, introducing musical accompaniments to the actions on the stage and adapting the speed of action to the plot of the play.

The authentic Yiddish-speaking national theatre was a creation of the joined forces of all concerned. It became a melting pot where many different talents met and synergized. A large part of this was due to Abram Efros, who took over as artistic director after the company moved to Moscow. It was his great achievement to attract Chagall, and also Isaak Rabinovich, Nathan Altman, David Shterenberg and Robert Falk, to the Theatre. A man of many talents, Efros is also known as a writer and art historian. He and Iakov Tugendkhold wrote the first monograph to appear on Chagall, published in 1918. Efros had recommended Chagall to Granovsky and was convinced that this young man from Vitebsk, capable of marrying the new ideas of the Western European avant-garde with a deep-seated love for everyday Russian life and the culture and customs of the common people, would be able to give new impetus to the Yiddish national theatre.

Chagall was commissioned to design the set and costumes for an evening of three one-act plays by Sholem Aleichem, which were to open the first season of the State Jewish Chamber Theatre on 1 January 1921. The plays were *The Agents* (fig. 14), *Mazeltov* and *The Disturbed Passover*,[5] the last two being dramatisations of stories of the same names. *The Disturbed Passover* was soon dropped and replaced by the one-act play *It's a Lie*. The evening was later extended to include another one-act play, *The Divorce*, and ran from 1924 under the title *The Masks of Sholem Aleichem*. For many years it was to remain part of the core repertoire of the Jewish Theatre.

The rehearsals of *The Agents* and *Mazeltov* had begun in Petrograd before the move to Moscow. When Chagall was commissioned the sets had been largely decided on, which was bound to make collaboration more difficult, since producer and painter often had divergent views on the best way to interpret Sholem Aleichem visually for the stage. Continuing the tradition of his earlier designs, Chagall created typically wild and fabulous sets, incorporating a variety of juxtaposed objects, some of which were literally upside down. The set for *The Agents* consisted of a toy locomotive crawling up an incline (cat. 43). *Mazeltov* was set in a kitchen; above the cooker there is a table covered in Hebrew characters,[6] and an upside-down goat was painted on the wall (figs. 15, 16). A segment of a huge, black circle threatened the small group of neatly arranged stools – a Suprematist foreign body (cat. 40). In *It's a Lie* a pair of huge legs and feet poked out from the side of a wall turned on its side, bearing a street lamp, as though one of Chagall's floating figures had drilled its way into the wall (cat. 46).

There was a massive row, when, on the opening night, Granovsky wanted to hang an ordinary teatowel on the stage. It came from an earlier production of the play for which the list of

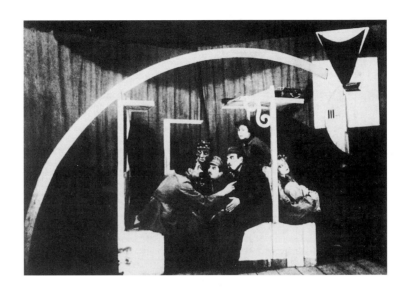

14. Production photograph of *The Agents*, 1920s

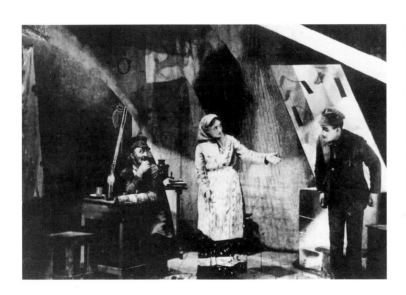

15. Production photograph of *Mazeltov*, 1920s

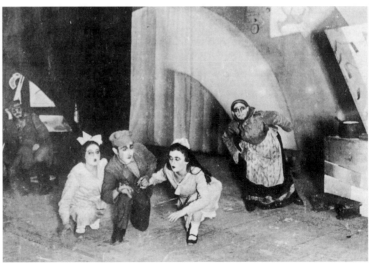

16. Production photograph of *Mazeltov*, 1920s

props has survived: 'A bag with books, a basket with books, three frying pans, three saucepans, four bowls, a sink, several piles of crockery, fruit (six to eight pieces), a simple teacup, a tray'.[7] Chagall insisted doggedly on fighting against realistic props. He would not accept that the actors should wear real frock coats and peaked caps on stage. They had to be transformed into works of art. Tiny houses with tiny gardens as well as finely traced characters appeared on their trousers, and birds and little pigs on their hats. Like a man obsessed, the artist liberally covered the costumes of the principal characters with every sort of drawing possible. The costumes of many actors were delivered only shortly before the premiere, to be transformed immediately by Chagall's brush and paint into elements of the overall artistic image he wanted to create. 'Shortly before the theatre opened I was brought old, used suits. I quickly painted them. In the pockets I discovered cigarette ends and breadcrumbs.'[8] Chagall made a point of using symbolic letters or characters, a device often employed in Cubism. Decorative words, sentences or simple letters in Hebrew characters appeared both in the stage sets and on the actors' costumes. The trousers of one character in *The Agents*, for example, were completely covered in lines of characters. With this sort of ornamentation any real objects used were transposed to a different plane.

Photographs and eye-witness accounts reveal that Chagall won through. Not only was the offending teatowel banished, but the principal character, played by Mikhoels (fig. 13), 'drinks imaginary tea and eats non-existent food'.[9] Mikhoels understood Chagall better than anyone else at the theatre. Artist and actor had a great deal in common: they were almost exactly the same age, were born and grew up in the same milieu of the ghetto in a small provincial town in Russia. Mikhoels was also from a Hasidic family. Chagall described vividly how Mikhoels studied his sketches for the set and costumes, burying himself in them. He looked at his role in the light of these sketches, and played it accordingly.

Chagall's victory was Pyrrhic, however. He was declared 'unethical', unsuited to work in the theatre. His work, it was claimed, was 'art for art's sake'. This damning assessment came from Efros himself. At the peak of the controversy Efros accused Chagall of wanting a theatre without actors. According to him, 'The artist dreamt of another possibility: a theatre without actors where only coloured canvas played a part. "Oh, if only there were no people!" Chagall let slip during work on the production, in the heat of the moment.'[10]

In fact this was far from being Chagall's intention. But the theatre he had created was not in line with the ideas of his collaborators: '... nothing came of our love affair – one of Granovsky's expressions', the painter noted sadly in his auto-biography. He was unable to work according to somebody else's ideas. He could be creative only for himself. A few years later Efros wrote about this time, 'Poor dear Chagall! He, of course, thought that we were tyrants and that he was the victim. This goes so deep that in the eight years since then he has studiously avoided all contact with the theatre. He never understood that he was the clear, unassailable victor, and that his victory made things extremely difficult for the young Jewish theatre.'[11]

Since the stage was tiny, he felt inhibited, cramped in his scope to express himself, and decided to decorate the entire auditorium as well. In this, to some extent, he was following the tradition of the numerous cabarets and clubs that had sprung up all over Russia in the decade leading up to the Revolution, of which the best known were the 'House of Interludes', 'The Bat', 'The Stray Dog' and 'The Comedian's Halt' already mentioned, for which Chagall worked in 1917. In these small rooms the action on the stage included and embraced the audience, blurring the divisions between stage and reality – on one occasion, for instance, the painter Sergei Sudeikin had dressed the waiters and doormen of the cabaret in theatrical costumes, thus giving them walk-on parts.

Within one short month, working day and night, the painter had finished this Herculean task, which in the history of Russian culture may be compared with Pushkin's celebrated 'Boldino autumn', a remarkably productive period in the poet's life spent on the family estate at Boldino in autumn 1830. His paintings covered the ceiling and every wall of the auditorium. He seemed to have suffered from *horror vacui*, unable to leave any space, however small, unpainted. On the ceiling he apparently painted a variation on his favourite theme of *Flying Lovers* (this is now lost);[12] on one long wall of the room, without windows, he created the huge composition *Introduction to the Jewish Theatre* (cat. 31); on the opposite wall, between the windows, he painted four vertical subjects *Music, Dance, Drama* and *Literature* (cat. 32–35), and above the windows in a narrow frieze *The Wedding Feast* (cat. 36). At the end of the auditorium opposite the stage, where the audience entered the room, he painted *Love on the Stage* (cat. 30), almost square in format. The total area painted was some 470 square feet (43.5 m^2). The auditorium became known informally as 'Chagall's Box'. All the murals were executed in tempera and gouache on canvas which could be taken down and thus preserved later.

Chagall made his *Introduction to the Jewish Theatre* an introduction in both a metaphorical and a symbolic sense. In one and the same composition he incorporated portraits of real people and imaginary characters from his vivid dreams – rather like the combination of the secular and the heavenly in Renaissance frescoes. The focus of the painting is a portrait of Efros, who is carrying Chagall into a room of the theatre world – an idiosyncratic echoing of the theme of the Presentation in the Temple. Alongside the central Efros pirouettes Granovsky, his feet apparently moving of their own accord, a state of affairs that has

perhaps occasioned his deeply concerned expression. Above the heads of Efros and Chagall and to Granovsky's left their surnames are written in a curve in Hebrew letters. The artist took the liberty of a joke, writing Chagall and Granovsky not from right to left as would have been correct Hebrew, but from left to right, as is usual in Latin and Cyrillic script.[13] This ironically painstaking labelling plays upon Old Russian religious icons and frescoes, in which the name appears over the head of the character represented.

Chagall is greeted on his arrival at the 'theatre' by a dwarf-like character, modelled on the actor H.S. Krashinsky, and an improvised orchestra. A figure in a frock coat and peaked cap is conducting a lively tune, to the beat of which the star, Mikhoels, is dancing. In the role of the 'wedding musician' we find L.M. Pulver, the theatre's resident composer. The composer, a flautist, a goat with a canny expression and a dancer are all placed on a disc which, rather like a gramaphone record, turns about a central axis that is the violinist, whose head, complete with jester's hat, cannot keep up with the rotation, and, rocking to and fro, liberates itself from his body Mikhoels appears three times in the painting – as one of the dancers in the middle, at the far left with a violin, doing the splits, and once in normal dress, with a tie and a hat, behind the circus artistes standing on their heads. Throughout his life Chagall would return again and again to this iconography of clowns and acrobats, which appears for the first time on the canvases of the Jewish Theatre.

The right-hand part of the *Introduction* is a scene typical of Chagall, in which trivial, everyday life takes on a fabulous enchanted allure, and is transformed into an enigmatic drama. Granovsky appears again, perched happily on a stool, looking down at the scene below him as though from a theatre box. His impervious, supercilious expression in profile is in delicious contrast to the bathetic footbath in which his bare feet indulge almost all on their own. Chagall's portraits of Granovsky in the mural were intended to represent the two sides of the nature of the producer, the sophisticated European and the down-to-earth man of the people.

As Granovsky takes his footbath a cow floats past. It is difficult to tell what is up and what is down for the animal. In the bottom right-hand corner a small figure relieves itself while, next to it, in a different colour zone, there is a violinist with a bird on his shoulder. His elbow is leaning on the gates of the Jewish cemetery in Vitebsk The canvas is full of the extraordinary, curious and wonderful. The entire painting is covered in geometrical squares, triangles and segments of circles, which dance across the surface like shafts of light. It is the universe itself, the cosmos which regulates this enchanted performance, in which 'low' life is mixed with the poetry of art. The blazing bands of colour, shimmering in every colour of the rainbow, can suddenly change in the spotlight and illuminate the production and the applauding public, or can act

as a screen, from behind which the head of an actor peers. Reality and folklore, banality and unreality, fact and myth are interwoven.

Having first visited Paris in 1910 in the early heyday of Cubism, Chagall could not ignore the avenues opened up by this new art movement. The geometric surfaces, broken views and distortions of Cubism are, however, modified in his work. They are subjugated to the emotional structure, to the demands of the artist's vision. Chagall took the same approach to Suprematism, which he came to know well when Malevich arrived in Vitebsk in November 1919. The coloured areas in his murals are reminiscent of Suprematism, though they are used by Chagall to heighten the rhythm and dynamism of the painting. Ultimately the composition is inseparable from the elaborate figurative content of his paintings.

The four life-size figures placed in the intervals between the windows on the opposite wall depict the traditional muses of the Jewish theatre. They are a borrowing, both ironic and in earnest, from the centuries-old tradition of decorating theatres with allegorical personifications. Chagall portrays the essential constituents of the national Jewish theatre in the form of the *badchan* (the minstrel and jester at Jewish weddings), the violinist, the *schadchan* (marriage broker), and the scribe, copying down the holy scriptures, the Torah. In the imagination of the *badchan*, who entertained the guests during the wedding feast, originated *Drama* (cat. 34). The green-faced beggar, busking on the streets of Vitebsk with his violin, is an archetype in Chagall's work, but here represents *Music* (cat. 32). The curvaceous *schadchan*, oblivious to her surroundings as she dances to the Jewish wedding melody 'Voice of the groom, voice of the bride' (the words of which are written in Hebrew round the bottom of the yellow curve), represents *Dance* (cat. 33). All three spiritedly join in the wedding celebrations, and the resonant joy of the occasion is mirrored in their lively gestures and poses. Embodying *Literature* (cat. 35), the scribe, a poet lost in his dreams as he copies the Torah, appears to be far removed from the boisterous celebrations of the ordinary people. Yet an echo of the celebrations and fun can be found in the humanoid face of the nearby cow, trumpeting the name of Chagall in Hebrew.

The long frieze showing the wedding table with all the ritual dishes, stretching the entire length of the wall above the four allegorical figures, served to heighten the festive, ceremonial atmosphere which surrounded the celebration of the wedding.

Slightly different from Chagall's habitual figuration, *Love on the Stage* (cat. 30) on the end wall opposite the stage is based on the *pas de deux* of classical ballet. The disembodied silhouettes of the ballerina and her partner have been liberated from their traditional ballet poses to follow a choreography of circles, squares, lines and triangles. The lyrical superlatives of the ecstasy of love are balanced, as is typical of Chagall, by another down-to-earth scene.

Two figures, dwarf-like in comparison to the main figures, sit like musicians in an orchestra pit. In the light of their oil lamp the boards of the stage look like a table top. The ballet shoes of the ballerina bear the words, 'Yiddish Theat(re)'.

'Chagall's Box' was a feast for the eyes. The brightly painted figures and objects in perfect harmony of colours stood out magnificently against the ochre background. The tiny monochrome drawings accentuated the main themes. The theatre curtain, too, was integrated into the overall scheme of the auditorium, bearing, when closed, the symmetrical profiles of two goats facing one another. Only a sketch of the curtain with its magical white affronted beasts has survived (cat. 29). Chagall himself added the date 1918 to the sketch, although it cannot have been done before 1920.

While still in Petrograd, the Yiddish Theatre had attempted in vain to make the breakthrough to become a major, professional, municipal and academic theatre. It partly had Chagall to thank for its return to the small scale, where it belonged, and in which form it played a significant role in developing theatre inside and outside Russia. It was this theatre, with its experimental approach, that opened the door to the development of radically new theatrical forms.

Chagall was all too aware of the significance of his murals for the Yiddish Theatre. He therefore fought to make them accessible not only to theatregoers, but to as wide a public as possible. At his instigation two art exhibitions were held in the Theatre in Great Chernichevsky Street, in 1921 and 1922, and the murals of the auditorium were their focal point. Public readings, exhibitions and concerts were also held. The second exhibition included works for the theatre by Nathan Altman and David Shterenberg. Both exhibitions received full press coverage.

The company's phenomenal success meant that by the end of 1921 it could move to larger premises, the former Romanovka Concert Hall in a building built around 1890 in Malaia Bronnaia Street, although studio productions were still held in the old premisses until 1924. At that point Chagall's canvases were transferred to the new foyer on the first floor of the new building, but obviously no longer in the positions intended by the artist because the layout of the rooms was different. In 1947 the canvases were removed, rolled up and stored underneath the stage with old sets. In 1948 the murder of Mikhoels signalled the start of a pogrom. The State Jewish Theatre was destroyed. In 1950 the commission for the liquidation of the Jewish Theatre handed over Chagall's work to the state-owned Tretiakov Gallery. This, at least, is the version of events one finds in the official records.

In the Moscow theatre world the story is told slightly differently, as I learned in October 1975 from A.V. Asarkh-Granovskaia (1892–1980), former actress and wife of Granovsky.

This version holds that the artist Aleksandr Tyshler, linked to the Jewish theatre over many years and a passionate admirer of Chagall, was responsible for saving the canvases. It is said that he carried Chagall's paintings on his own back to the Tretiakov Gallery, since he knew that otherwise they were doomed.

For more than forty years the canvases were only once unrolled, in front of Chagall himself. The ageing artist, who had returned to his home country in 1973 for the first time since his exile, had expressed a burning desire to see the works from his youth again. On this occasion Chagall signed the paintings in printed Cyrillic characters – a signature rarely found on his work – and dated them.

The fate of the ceiling canvases of the Jewish Theatre is uncertain, but we must assume that they have been lost. 'Chagall's Box', which was later only one of many rooms in a crowded communal apartment, housed the family of a Red Army general from the 1930s to the 1960s. According to former tenants of the building there was a large raised podium at one end of the general's room – previously the stage. It was turned into a bedroom. The tenants also remember small pieces of plasterwork, some of which still showed traces of the gold they once bore, running along the walls and around the darkened rosette in the middle of the ceiling. Is it possible that Chagall's *Lovers* lay concealed and followed the daily life of the occupants, unseen, unsuspected? The house was converted into an office building at the end of the 1960s. Today computers stand where previously Chagall's immortal works graced the walls.

In subsequent years Chagall would keep returning to the themes and motifs of the murals. Even in the tragic days of the Second World War in 1944, when he had heard of the fate of his hometown of Vitebsk and its inhabitants, the year in which his wife Bella died, he painted *The Harlequins*, the basic pattern of which follows the composition of *Introduction to the Jewish Theatre*. Symbolically he dated it 1922–44. In it a bizarre procession of actors and musicians move through the streets of a dark, snow-covered Vitebsk. The procession is joined by Chagall's ever-present characters – the bearded Jew and the two immortal lovers. Chagall is no longer carried by Efros, but by a simple villager, though 'Mikhoels' dances, and the disc with the headless violinist turns ... The long lost happiness of the time spent at the Moscow Theatre and the lost paradise of Vitebsk fuse in the dramatic, oppressive note of this work of memory.

In the last quarter of his long life Chagall worked time and again for the theatre. He painted a ceiling decoration for the Opéra in Paris and huge wall paintings for the New York Metropolitan Opera, and designed the sets for the ballets and operas *Aleko* (1942), *The Firebird* (1945), *Daphnis and Chloé* (1958) and *The Magic Flute* (1967), strongly influencing the choreography and the production in each case.

Notes

1. *Teatralnaia Moskva*, nos. 17–18, 1921, p. 27.

2. 'TEREVSAT – In December TEREVSAT is to stage the première of the play *Khlestakov*, by D. Smolin, produced by David Gutman, stage-set designed by Marc Chagall', *Ekran*, no. 12, 1921, p. 12.

3. Cf. Franz Meyer, *Marc Chagall: Life and Work*, New York, 1960, p. 286.

4. Cf. Marc Chagall, *My Life*, Oxford, 1989, p. 160.

5. In the source material on the history of the State Jewish Chamber Theatre and the State Jewish Theatre collected by I.M. Kleiner and in deposit at the Bakhrushin Theatre Museum in Moscow, there is the following mention: '1 January Inauguration of the 2 seasons (1920/21) of the State Jewish Chamber Theatre in Moscow in the building of the Studio at Chernichevsky Street in the so called "Chagall Hall". It shows a Sholem Aleichem performance consisting of *The Agents*, *The Disturbed Passover* and *Mazeltov*. Direction Al. Granovsky, stage-sets Chagall, Music Achron.' (Manuscript Department of the Central State Bakhrushin Theatre Museum F. 584, inv. no. 93, p. 1).

6. These letters can be read as 'Sholem Aleichem', the answer to the traditional Jewish greeting (Peace be with you).

7. Manuscript Department of the Central State Bakhrushin Theatre Museum F. 584, inv. no. 99, p. 2.

8. Cf. Chagall, *My Life*, 1989, p. 162.

9. See note 7.

10. Cf. Abram Efros *The Artist and the Stage*, Theatre Culture, Moscow, 1931, p. 203.

11. Cf. Abram Efros, *The Artists of the Granovsky Theatre*, in *Marc Chagall: The Russian Years, 1906–1922*, exhibition catalogue ed. Christoph Vitali, Frankfurt, Schirn Kunsthalle, 1991, p. 91.

12. A. Asarkh-Granovskaia describes the subject of the ceiling in her unpublished memoirs as that of Chagall's favourite theme of the 'Flying Lovers'. There are only few reports on the ceiling of the Yiddish Chamber Theatre.

13. For the significance of the Hebrew inscriptions as well as the relationship between some of the iconographic motives used by the artist and the traditional subjects of Jewish folk art, cf. Benjamin Harshav, 'Chagall: Postmodernism and Fictional Worlds in Painting', in *Marc Chagall and the Jewish Theatre*, exh. cat., Solomon R. Guggenheim Museum, New York, and The Art Institute of Chicago, 1992, pp. 15–63; and Benjamin Harshav, 'L' Introduction au Théâtre Juif', in *Marc Chagall: Les années russes*, exh. cat., Musée d'art modérne de la Ville de Paris, 1995, pp. 200–22.

1. *Introduction to the Jewish Theatre*
2. Between the windows: *Music, Dance, Drama, Literature*
3. Frieze: *The Wedding Feast*
4. Entrance wall: *Love on the Stage*
5. Ceiling (*The Flying Lovers*)
6. Curtain

16. Reconstruction of 'Chagall's Box'

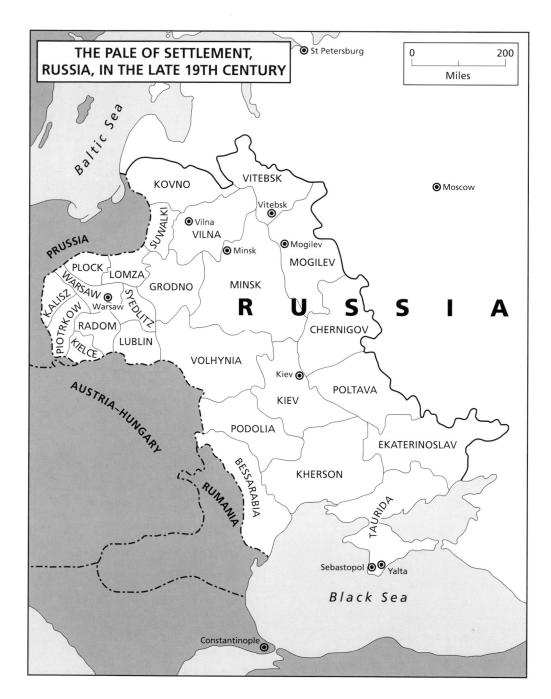

THE PALE OF SETTLEMENT, RUSSIA, IN THE LATE 19TH CENTURY

0 — 200
Miles

St Petersburg

Baltic Sea

KOVNO

VITEBSK

Vitebsk

Moscow

SUWALKI

Vilna

VILNA

PRUSSIA

PLOCK

LOMZA

Minsk

Mogilev

MOGILEV

KALISZ

WARSAW

GRODNO

MINSK

SYEDLITZ

Warsaw

PIOTRKOW

R U S S I A

RADOM

CHERNIGOV

KIELCE

LUBLIN

VOLHYNIA

Kiev

AUSTRIA-HUNGARY

POLTAVA

KIEV

PODOLIA

EKATERINOSLAV

BESSARABIA

KHERSON

RUMANIA

TAURIDA

Sebastopol Yalta

Black Sea

Constantinople

18. Map of the Pale of Settlement

The Quest for a Jewish Art in Revolutionary Russia

Monica Bohm-Duchen

THROUGHOUT HIS LONG CAREER, Marc Chagall was loath to acknowledge the full extent of his debt to other artists and to cultural movements of any kind, preferring to encourage an image of himself as a solitary, intuitive and self-sufficient individual. Similarly, although in his art his Jewishness is everywhere in evidence, he was deeply wary of the label 'Jewish artist', choosing instead to stress the universality of his work. Recent scholarship, however, sceptical of these attitudes and aided by the new material available on the artist since Glasnost, has led to a radical reassessment of Chagall's position vis-à-vis his contemporaries. Nowhere is this more dramatically demonstrated than in an examination of the years 1914–22.

Chagall's output during these years cannot be fully understood without reference both to the lively debates about Jewish culture circulating in Russia at the time and to the collective endeavours to which these gave rise. Assimilation and secularisation came to the Jews of Russia far later than to those of western Europe, where the French Revolution of the late eighteenth century is commonly seen as a crucial landmark in the emancipation of the Jews and the emergence of the Jewish Enlightenment or Haskalah. In contrast, until the 1917 Revolution, the vast majority of Russia's five million, predominantly Yiddish-speaking Jews were forced to reside in the so-called Pale of Settlement (fig. 18), living for the most part in the small, almost exclusively Jewish towns and villages known as *shtetls* or in larger towns such as Vitebsk and Minsk where they formed a substantial majority. Mainly poor and pious, and constantly fearful of anti-Semitic attacks, they maintained a religiously, linguistically and culturally distinct way of life.

The visual arts played a larger part in these communities than is usually acknowledged. Indeed, the taboo on 'graven images' contained in the Second Commandment has been far less consistently adhered to by the Jews than is commonly believed. The prohibition needs to be seen in its original biblical context, of Israel seeking to establish monotheism in a sea of idolatry. Later, when the context changed, the Jewish attitude to figurative art varied considerably from area to area and from period to period, for reasons as often political as religious. Before the nineteenth century, however, Jewish art tended to be the work of usually anonymous craftsmen (not all of them Jewish) intent on adorning places of worship or on producing ritual objects for use in the home or synagogue, to the greater glory of God.

The political and social emancipation of the Jews and their increasing secularisation meant that by the late nineteenth century Jewish artists – in the post-Renaissance sense of the word – were beginning to make their mark all over Europe, without having to suppress every trace of their Jewishness, as had hitherto been the case if they wished to succeed in a non-Jewish environment. Max Liebermann in Germany, Jozef Israels in Holland and Camille Pissarro in France are only the best known examples. Moreover, with the gradual emergence of a Jewish bourgeoisie in western Europe came the demand for naturalistic genre paintings depicting the traditional way of life it was in the process of abandoning – often in a nostalgic, even sentimental light. Artists such as Moritz Oppenheim in Germany and Leopold Horowitz and Isidor Kaufmann in Austria-Hungary made a good living meeting this demand.

In Russia the trail-blazer was the sculptor Mark (born Mordechai) Antokolsky, held up to subsequent generations as a shining example to which to aspire. (Indeed, Chagall may well have changed his name from Moissey to Marc in homage to the older artist.) Born in Vilna in 1843 into a poor religious family, Antokolsky achieved the distinction of becoming the first – and at the time, only – Jewish student at the Imperial Academy of Arts in St Petersburg. By the mid-1860s, encouraged by Vladimir Stasov, the influential non-Jewish art critic, he had won a considerable reputation for himself as the maker of realistic sculpted images of Jewish life and history. By the mid-1870s, although remaining religiously observant, he had abandoned overtly Jewish subject-matter. This did not, however, protect him from virulent anti-semitic attacks on his supposed effrontery in dealing with Christian and Russian themes. His depiction of Jesus as a young Jew complete with orthodox sidecurls (fig. 21) was deemed particularly outrageous. Deeply embittered, he reacted by becoming a keen supporter of the artistic efforts of younger Jewish artists.

Even provincial Vitebsk boasted its own Jewish artist, Yehuda Pen (see fig.20), Chagall's first teacher, born in 1854 in the small town of Novo-Aleksandrovsk in Lithuania, who in 1897 opened his School of Drawing and Painting in Vitebsk – the first predominantly Jewish art school in the Russian Empire. Pen was a member of a group of young Jews who, thanks in part to the precedent set by Antokolsky, were able to study at the Imperial Academy of Arts in the 1880s. An association in the 1890s with the painter Ilia Repin, leading member of the Wanderers group, further encouraged Pen to embody the ideals of both Antokolsky and Stasov in his own work. The anti-academic, democratising ideas of

19. Marc Chagall, *Jew in Black and White [The Praying Jew]*, 1914,
Private Collection

20. Yehuda Pen, *Morning Chapter from the Talmud*, before 1912,
Museum of Regional and Local History, Vitebsk

21. Mark Antokolsky, *Ecce Homo*, 1873,
State Tretiakov Gallery, Moscow

the Wanderers had eased the way for Jews who sought access to the mainstream art world, thus enabling the painters Isaak Levitan, Leonid Pasternak and Boris Anisfeld to emerge as successful artists. The otherwise anti-Semitic climate of that period meant, however, that these artists, and those who followed them – Pen's fellow Jews at the St Petersburg Academy included the sculptor Ilia Ginzburg and Moses Maimon (like Pen, primarily a Jewish genre painter) – tended to stick together for solidarity, all too well aware of the problems, as well as the challenges, still facing the Jew who aspired to be a professional artist.

It is clear, therefore, that Chagall's retrospective claim in *My Life*, 'But a word as fantastic, as literary, as otherworldly as the word "artist" – well, I might have heard of it, but it had never been uttered by anyone in our town,' was a gross exaggeration, made presumably to dramatise the inauspiciousness of his origins. The word 'artist' may indeed have been an alien one to Chagall's devout, working-class parents; but there were other Jews, more affluent and secularised, for whom this was no longer the case.

Indeed, by the late nineteenth century, a growing cultural self-consciousness had manifested itself among a minority of Jews, mostly rich Russian-speaking merchants, lawyers, doctors and intellectuals who lived in the larger metropolitan centres (above all, St Petersburg), more oriented to the West than the rest of the Jewish population yet still anxious to preserve a distinctive identity. Maxim Vinaver, Chagall's first major patron, an eminent lawyer and politician, was active in this sphere; like a number of the artist's other early supporters, such as the critic Maxim Syrkin and the writer and social historian Solomon Pozner, he was closely associated with the newspaper *Novyi Voskhod* (New Dawn), one of several Russian-language publications intent on encouraging the development of a lively, secular Jewish culture.

One of the earliest manifestations of this wish to celebrate and reinforce a distinct cultural identity was the compilation in 1886 by Stasov, in collaboration with the scholar and philanthropist Baron David Ginzburg, of a volume devoted to medieval illuminated Hebrew manuscripts mainly from the Imperial Library of St Petersburg. Entitled *L'Ornement hébreu*, it was published in Berlin, in a French-language edition, in 1905. In his preface, Ginzburg emphasised Stasov's crucial role in mobilising others: 'He reproached the Jewish nation for its complete indifference regarding the products of its national genius, he sought out, he discussed, he commented, he stirred minds and resolved to prove his fertile thought by publishing these plates and exposing his theories.' The text by Stasov claimed that specifically Jewish traits could be traced in the manuscripts irrespective of their geographical source. Although criticised and refuted on scholarly grounds, the publication was widely admired by those intent on a nationalist cultural renaissance, and may well have influenced

Nathan Altman, El Lissitzky and others – including Chagall – in their bold use of Hebrew calligraphy several years later.

The main spokesman for the populist Wanderers movement, Stasov actively encouraged the artistic expression of Russia's ethnic diversity. Aware both of the existence of the Palestine Exploration Fund, established in 1865, and of the showing of the Strauss Collection of Judaica at the 1878 World Exhibition in Paris, he subscribed wholeheartedly to a realist credo and urged Antokolsky and other Jewish artists to find their true subject-matter in their own culture. In 1878, for example, he wrote fervently of his belief that '... the highest achievement in art derives from the depths of a people's soul. What the artist is born with, the impressions and images that surround him, among which he grew to manhood, to which his eye and soul were riveted, only that can be rendered with deep expression, with truth and genuine force.'

In the early part of the twentieth century several organisations intended to foster an interest in indigenous Russian-Jewish culture were established. Notable among them was the Jewish Historical and Ethnographical Society, founded in St Petersburg in 1908. Prominent among its members was the writer and scholar Shloyme Zanvil Rapaport, better known as S. Ansky (author in 1919 of the play *The Dybbuk*), who from 1909 onwards published articles on Yiddish folklore, and between 1912 and 1914 headed a major ethnographic expedition into remote areas of the Pale of Settlement. (Its findings were deposited at a short-lived Jewish National Ethnographic Museum, established in 1916 but closed down by the Bolsheviks in 1918.) The expedition, funded in part by Baron Horace Ginzburg, banker, owner of railways and mines and Jewish Maecenas, was composed largely of students from the Jewish Academy (officially and euphemistically known as 'Courses in Oriental Studies') at the University of St Petersburg; it was accompanied by a photographer, a musicologist and a painter and graphic artist, Solomon Yudovin, a former pupil of Yehuda Pen. Songs, proverbs, legends, superstitions, rituals and customs were recorded; photographs, clothing, amulets, documents, manuscripts and numerous other objects assiduously collected.

The artefacts gathered on these forays into the towns and villages of isolated regions such as Volhynia and Podolia were to have a lasting impact on a whole generation of Jewish avant-garde artists. In an essay of 1918 entitled 'Aladdin's Lamp', the critic Abram Efros (co-author in that year of the first monograph on Chagall, and soon to become artistic director of the Yiddish Chamber Theatre), claimed in no uncertain terms: 'The *lubok* (woodblock print, see fig. 22, p. 39), the gingerbread, the toy and the painted cloth constitute an entire programme for the practical aesthetics of contemporaneity If Jewry wishes to live aesthetically and if it is looking for its aesthetic future, then this presupposes an inexorable, thorough and total connection with the popular arts.'

Although Stasov's lingering influence can still be detected in such statements, it is less in the Wanderers' realistic aesthetic than in the primitivising impulses of younger artists such as Mikhail Larionov and Natalia Goncharova, who sought inspiration in Russian icons and folk traditions, that stylistic parallels with the Jewish avant-garde can be found. Indeed, this interest in 'primitive' art was international, combined in many cases with an admiration for the art of children and the insane – all of which served to confirm the avant-garde's belief in the superiority both of non-naturalistic forms and of an art rooted in emotions and deeply held beliefs. Although the Jewish artists were geographically and historically closer to the culture to which their art referred than most other avant-garde groups, they too took from their sources only what suited them. Ironically, their encounter not only with synagogue decoration and ritual objects, but with lubki and items of domestic use, came precisely at the point at which the way of life they represented was being eroded by the forces of modernity, above all in the form of Zionism and socialism. Undeterred, the artists formed their own conclusions, stating their case with a passion that often smacked of wishful thinking and led to curious, sometimes blatant biases, evasions and circular arguments.

In marked contrast to the emphasis on explicitly Jewish subject-matter that characterised the work of an earlier generation of artists such as Antokolsky or Pen, but in common with the international avant-garde's generally anti-realist stance, the Russian Jewish artists of the early twentieth century claimed that true Jewishness lay not in iconography but in formal properties. In 1919, for example, Boris Aronson and Issachar Ber Ryback published an important article entitled 'Paths of Jewish Painting' in the Kiev-based Yiddish journal Oyfgang, in which they dismissed Antokolsky for being 'a Jew according to his life conceptions, but not according to his plastic conceptions It is the emphasis on formal aspects rather than the subject-matter which reveals the true racial identity of the artist.' According to them, and to others too, among them Yudovin and Yeheskel Dobrushin (writer, critic, teacher and founder-member in 1918 of the Kiev Kulturlige, a secular Yiddish cultural organisation), the principles of Jewish folk art included deep, dark and rich colours, autonomy of Hebrew lettering, flatness, non-hierarchical ornamental design, and a tendency to abstraction and symmetry – all of which they could conveniently transpose into their own productions.

To Aronson and Ryback, Chagall occupied a place of honour, due to the way in which he 'in an abstract form, partially uncovered both his own painting style and national substance'. 'Of all the Jewish artists he is the only one to have understood, appreciated and partially recreated, poetically, the Jewish plastic folk-trait. To the question, how has Chagall demonstrated his picturesque material, we may respond: being a product of Jewish culture, Chagall has also demonstrated his national form. That is his great merit, and he is thus the first one entitled to bear the name "Jewish artist".' Ironically, however, the painting they single out for special praise is his Praying Jew of 1914 (fig. 19, p. 36), the formal properties of which can hardly be dissociated from its unequivocally Jewish subject-matter.

Many of these artists actively sought out the folk art they so much admired. In 1913, for example, Altman spent the summer in the province of Volhynia, studying and copying the tombstones of Shepetovke, which formed the basis for his series of drawings entitled Jewish Graphics (fig. 23), first exhibited in 1916 in Petrograd and published in book form in Berlin in 1923. In 1916, the Jewish Historical and Ethnographical Society commissioned the artists Ryback and Lissitzky to explore and record the art and architecture of the wooden synagogues along the river Dnieper. El (born Eliezer) Lissitzky had already shown a marked interest in traditional Jewish art forms: while an architecture student in Darmstadt, Germany, between 1909 and 1914, he had made a study of the eleventh-century synagogue at Worms, the oldest in Europe, and would have encountered the famous fifteenth-century Darmstadt Haggadah. Based in Moscow after his return to Russia, Lissitzky was one of the prime movers behind the pre-Revolutionary movement to create an authentic Jewish art, sharing his contemporaries' enthusiasm for indigenous Russian-Jewish folk art. His illustrations of 1917 to Moshe Broderzon's Small Talk (Sikhes Kholin, also known as The Legend of Prague) reveal a self-consciously archaising quality almost certainly inspired by ancient Hebrew manuscripts. The charming, faux-naïf illustrations to A Kid for Two Farthings (Had Gadya) that he produced in 1918–19 (fig. 25, p. 40) and for The Mischievous Boy (Yingl Tsingl Khvat) of 1919 by Mani Leib bear out Chagall's claim in My Life that Lissitzky was at that period 'my most ardent disciple', but their vigorously 'primitive' graphic qualities are to be found in the work of several Jewish artists at this time.

The paintings that Ryback later produced of some of these wooden synagogues reveal a deep reverence for their subject-matter, coupled with a strong, if eclectic, awareness of avant-garde styles such as Expressionism (as in The Synagogue of Chiklov of 1917) and Cubism (as in The Old Synagogue of the same year). The simple exteriors of these buildings now known to us only through records such as this, and through photographs, since virtually none survived the Second World War – gave little indication of the profusion of mural ornament within. Endearingly naive, these wall-paintings clearly possessed an infectious exuberance and vitality, an intuitive sense of surface pattern, comprised of architectural, organic and anthropomorphic animal forms.

Most notable were the paintings inside the eighteenth-century synagogue of Mogilev (fig. 24) – unusual not only for their quality

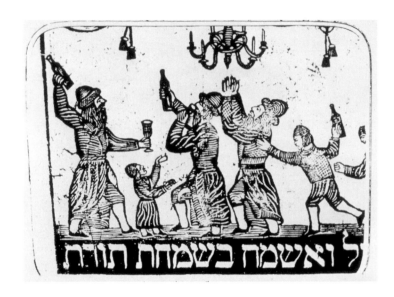

22. Jewish *lubok* (woodblock print)
depicting the festival of Simchat Torah, 18th–19th century

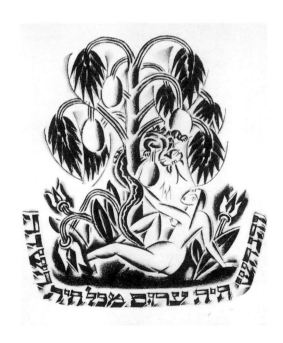

23. Nathan Altman, *Eve and the Serpent*,
from *Jüdische Graphik* (Berlin, 1923), The Israel Museum, Jerusalem

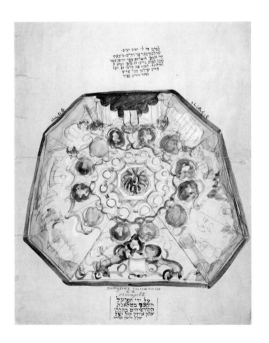

24. Issachar Ber Ryback, *The ceiling of Mogilev Synagogue* (detail), c. 1916,
The Israel Museum, Jerusalem

25. El Lissitzky, Illustration for *Had Gadya*, 1918–19,
The Tel Aviv Museum of Art

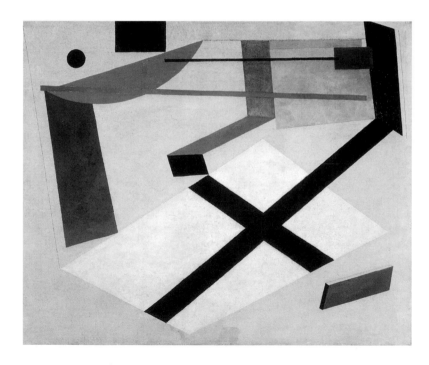

26. El Lissitsky, *Proun 30t*, 1920, Sprengel Museum, Hanover

but also for the fact that they bore the inscription, 'By the artisan who is engaged in sacred craft, Haim the son of Isaak Segal from Sluzk'. Significantly, it was this man, Haim Segal of Sluzk, one of the relatively few Jewish craftsmen whose name has been preserved, whom Chagall (born Segal) adopted as his (probably, but not necessarily) fictive ancestor. In 1923, Lissitzky published an essay in the Berlin journal *Rimon* entitled 'Memoirs concerning the Mogilev Synagogue', in which he vividly evoked his earlier sense of discovery: 'This was truly something special, like those surprises in store for me when I first visited a Roman basilica, a Gothic chapel, Baroque churches in Germany, France and Italy; or like a cradle, bedecked with a fine veil embroidered with flies and butterflies, in which the infant suddenly awakes in surroundings sprayed with sunlight; such perhaps, is how it looks inside the synagogue.'

Even before his departure for Paris in 1910, Chagall had encountered the debates about Jewish culture circulating in the pages of cultural journals such as the Berlin-based publication *Ost und West*, which flourished between 1901 and 1922, and to which we know that Pen was a subscriber. Although later affecting disdain for their fervour, he had also been well aware of the presence in Paris of the Machmadim (The Precious Ones), a group of young artists, most of them of Russian origin, preoccupied with developing a modern Jewish art based on a knowledge and appreciation of folk traditions. One reason for his impatience with their ardent theorising may well have been his realisation – one that, back in Russia, others would soon come to share – that his own art, with its overt, albeit complex, references to traditional Jewish art and life, was already embodying in an unforced and spontaneous way many of the ideas and principles that other artists were only talking about.

Be that as it may, in Petrograd during 1915–16, Chagall for the first time forged close contacts with a group of artists, comprising Lissitzky, Ryback, Aronson, Josef Chaikov (a former member of the Machmadim) and others, intent on exploring and exploiting Russian-Jewish folk art in their quest for an authentic modern Jewish art. His successful sojourn in the French capital, combined with the obvious relevance of his earlier work, lent him a certain glamour in the eyes of his contemporaries, who saw him as a paradigmatic figure. Altman, to whom Chagall related in a spirit of friendly competition, was a particularly active member of the group, helping – along with Chagall's old mentors, Ilia Ginzburg, Vinaver, Pen and others – to found the Society for the Encouragement of Jewish Art in Petrograd in late 1915 or early 1916. Chagall himself participated in the first exhibition of the Society in the spring of 1916; and in April 1917, fourteen of his paintings and thirty drawings were included in a controversial show entitled 'Paintings and Sculptures by Jewish Artists', staged by the Society and held at the Galerie Lemercier in Moscow. In the pages of the Moscow Yiddish journal *Shtrom*, Chagall defended the project, expressing his pride in belonging to 'this little Jewish people who gave birth to Christ and Christianity. When there was a need for something else [they] came up with Marx and Socialism. So why couldn't [the Jewish people] also give the world a specifically Jewish art?'

It was probably the Society for the Encouragement of Jewish Art which in 1916–17 gave Chagall his first public commission, to produce a series of paintings to decorate a Jewish secondary school adjoining the main synagogue in Petrograd. The extant studies – *Visit to the Grandparents*, *The Feast of Tabernacles* and *Purim* (fig. 27, p. 43), and two final sketches, one for *Purim* and one entitled *Baby Carriage Indoors* – reveal that he here abandoned the blend of realism and Cubism in which many of his paintings of this period had been rendered in favour of a more populist *faux-naif* folk style indebted to the tradition of Jewish *lubki* and painted wooden synagogue interiors. The outbreak of the Revolution, however, meant that the large-scale paintings for which these studies were intended were never executed.

Chagall's reaction to the February and October Revolutions of 1917 – like that of virtually all the artists mentioned above – was more enthusiastic than his previously apolitical stance would have led anyone – including himself – to expect. As a Jew and as an artist, he could not fail to be excited at the prospects opening up before him. For the Jews of Russia, the new order promised full citizenship for the first time: the liquidation of the infamous Pale of Settlement, an end to the *numerus clausus* in universities and to the internal passport system that had once landed Chagall in prison. For observant Jews (like Chagall's father Zakhar), the Revolution offered the hope that they would at last be able to practise their religion without fear of prejudice and persecution. Ironically, for already secularised Jews like Chagall, the Revolution promised to sweep away not only Tsarist tyranny, but the tyranny of Jewish tradition as well.

In cultural terms, as we have seen, the search for a relevant and authentic modern Jewish art in Russia substantially pre-dates the Revolution. It was only after 1917, however, that, for a few years at least, the collective dream of forging a distinctive artistic identity seemed realisable. After all, the 1917 Declaration of the Rights of the People of Russia announced 'the abolition of all national and national–religious prejudices and restrictions, and the full development of national minorities and ethnic groups'. Between 1917 and 1920, in the heady confusion of those times, everything seemed possible. In 1920, in keeping with the inexorable centralisation of power following the Bolsheviks' victory in the Civil War, the running of Jewish communal affairs was handed over to the EVSEKTSIA or Yevsektsiya, the Jewish section of the

Communist Party. In keeping with its avowed aim of Bolshevising the Jewish masses, it embarked on the gradual but systematic destruction of all traditional and nationalist Jewish aspirations. In 1930, Yevsektsiya itself would be completely subsumed into the vast Communist party machine.

In the short term, Chagall's energies – as befitting the new Commissar for Art in Vitebsk – were to be diverted to practical administrative tasks. Although this is not the place to dwell on the details of the internecine power struggles that raged in his art school (see p. 14), it is relevant to note Lissitzky's apparent switching of artistic allegiances from a Chagallian *faux-naiveté* (see fig. 25, p. 40) to the brand of purist geometric abstraction favoured by his new hero Kazimir Malevich, like himself a teacher at the Vitebsk Art Academy set up by Chagall. His *Proun (Towards a New Art)* series of 1919 onwards (fig. 26, p. 40) shows how far he was now travelling in a radically different direction. Yet, ironically, some of the graphic work that Lissitzky produced in Berlin in the early 1920s (notably, his 1922 illustrations to Ilia Erenburg's *Six Tales with Easy Endings*) represents a striking amalgam of Chagallian visual humour and Suprematist geometric rigour. Nor was Lissitzky averse to publishing his work in the journal *Rimon*, organ of the German-Jewish cultural movement. Only after 1925, the date of his return to the Soviet Union, did Lissitzky finally abandon all Jewish references in his work.

Suffice it to say that the bitterness engendered by those struggles and his ultimate defeat make it all the more understandable that Chagall should choose to work for the one institution that seemed to want him: the burgeoning Yiddish theatre. Viewed in a more positive light, the move from Vitebsk to Moscow enabled him to pick up the threads of his pre-Revolutionary interest in Jewish culture. Indeed, it was only in the theatre, which became a meeting-ground for all the arts, to some extent insulated from the outside world, that the pre-1917 fervour to create a specifically Jewish art form would be sustained until the mid-1920s, by which point it had faded, or been suppressed, in other areas of cultural activity. It was in 1920, therefore, that Chagall began to work for the State Yiddish Chamber Theatre (Gosudarstvennii Evreiskii Kamernyi Teatr or GOSEKT). (In Yiddish, the word 'Yiddish' means both Yiddish and Jewish, which is why, in English, the Theatre is also sometimes called the State Jewish Chamber Theatre.)

Yiddish, that richly idiomatic amalgam of German, Hebrew and various Slavic languages, spoken by Ashkenazi Jews since the Middle Ages, had long since been largely abandoned by the Jews of western Europe, but was still spoken by the vast majority of Russian Jews. Hebrew, in contrast, the sacred language of the Old Testament, was reserved for religious study and worship. The work of writers such as Chaim Bialik or even Isaak Loeb Peretz, who

chose to write in Hebrew as well as Yiddish, and the establishment in 1917 of the Hebrew-language Habima Theatre in Moscow were thus a deliberate, and necessarily controversial, attempt to recreate Hebrew as a modern, secular means of communication. Although initially more realist in orientation than the Yiddish State Theatre, the Hebrew Theatre gradually – due partly to Chagall's influence – became less stylistically conservative, employing avant-garde artists such as Altman (fig. 28, p. 45) to create stage designs for its productions. In due course, the Soviet regime grew increasingly suspicious of its activities, viewing them as Zionistic and subversive; in 1926 the company left Moscow for good, travelling in Europe for several years before making its permanent home in Tel-Aviv in 1931.

Until the end of the nineteenth century, there had been virtually no secular literary tradition in Yiddish, nearly all writings in that language deriving from religious texts or commenting on them. Only in the early twentieth century did a rich body of secular literature develop, represented above all by the writings of Sholem Yankev Abramovitz, better known as Mendele Mocher Sefarim (Little Mendel the Bookseller), Sholem Aleichem (born Sholem Rabinovitz) and I.L. Peretz. This literature is notable for its idiomatic vigour, its self-mocking and mordant wit, its vivid sense of the absurd and the fantastical, imbued in many cases with a residual element of Hasidic mysticism – all of these characteristic of much of Chagall's own work. Indeed, he knew several of the writers personally, and was intimately familiar with much of their writing as well as the Jewish world which had nurtured it. In 1915, moreover, he illustrated Peretz's humorous short story *The Magician* and two poems by Der Nister (The Hidden One, pseudonym of Pinkhes Kahanovich), thus paving the way for a more widespread interest in creating a secular Yiddish art book tradition. Between 1883 and 1905, however, and again from 1910 until the Revolution, all Yiddish publications were banned by Tsarist decree.

Yiddish drama went back a little further. Yiddish biblical drama, which adapted the Old Testament stories more freely than did any other literary genre in that language, had emerged in the late seventeenth century. Generally presented around the time of the celebratory festival of Purim, its basis was a lively oral tradition involving troupes of amateur actors (*Purimspielers*) who turned their hand to clowning, singing and acrobatics. Purim plays persisted in eastern Europe right up to the eve of World War II. Other important precursors of the new Yiddish theatre were the jesters (or *badchanim*) who performed in impromptu fashion at Jewish weddings and other festivities and the so called Broder Singers, itinerant male singers named after Berl Broder, reputedly the first such performer, who enacted comic musical sketches.

The modern Yiddish theatre was created almost single-handedly by Abram Goldfaden in the 1860s and 1870s, although

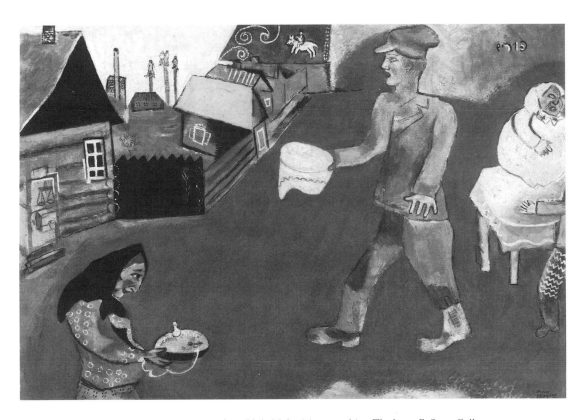

27. Marc Chagall, *Purim, c.* 1916–18, Philadelphia Museum of Art: The Louis E. Stern Collection

its beginnings can be traced to older dramatists such as Solomon Ettinger, who consciously used the new medium to introduce the secularising ideas of the Haskalah into the traditional communities of eastern Europe. Originally a rabbinical student in the Ukraine, Goldfaden first became involved in the theatre when he played the leading role in a Purim play. Abandoning his religious studies, he wrote and published several collections of Yiddish folk songs before joining forces with a troupe of Broder Singers in 1876 to present what became known as the first professional Yiddish theatre performance. Encouraged by its success, he recruited cantors' assistants and singers as actors, and for the first time found women to play female roles. Within a few years, his company was performing to great acclaim throughout Russia. Goldfaden's best known plays were romantic operettas on biblical themes (*Shulamith*), satirical comedies such as *Schmendrik* or more serious historical dramas like *Bar Kochba*. In aesthetic terms, these plays were hardly masterpieces, many of them relying heavily on the conventions of farce or sentimental melodrama. Their popular appeal, however, was considerable.

In 1883 the Tsar imposed a total ban on Yiddish theatre. Russian-Jewish audiences thereafter had to be content with traditional Purim plays and seeing the occasional clandestine troupe of German-Yiddish actors. After 1900, conditions eased, although they were never easy. Even the promise of freedom held out by the Revolution led in the short term to a period of total confusion. The Polish invasion of the Ukraine, civil war, pogroms and starvation were hardly conducive to an appreciation of the theatre among Russia's Jewish (or indeed non-Jewish) population. Eventually, however, the Revolution led to relative security for all theatres in Russia. The country had long had a tradition of theatres supported either by the state or by local noblemen: since the time of Goldfaden, Yiddish theatre had managed to exist somewhere in the interstices of this system. Now, for the first time, it became an official part of a large and increasingly organised Soviet cultural machine. Since 97% of Russia's Jewish population still spoke Yiddish, it was immediately obvious to the Revolutionary leaders that Yiddish had to be the linguistic means by which to convert the Jewish masses to a Communist way of thinking. So it was that the new regime lent active support to an increasing number of Jewish cultural institutions and publications, notable among them theatres performing in Yiddish.

In 1919 the Jewish section of the Communist Party appointed Aleksei Granovsky to establish a studio to train actors for a brand-new Soviet Yiddish theatre. The theatre started life in Petrograd, where the foundations for such an undertaking had been laid in 1916, when a Jewish Theatre Society had been established there; this resurfaced after the Revolution in the guise of a Yiddish Workers' Theatre, affiliated to the People's Commisariat for Education. The intention from the start was to create a theatre that bore little resemblance to the Yiddish theatre of the past – understandably, since pre-Revolutionary Yiddish culture was now identified with religion, separatism and bourgeois capitalism, all anathema to the new way of thinking. Granovsky himself was an assimilated Russian Jew who had trained in Germany and spoke no Yiddish; he deliberately selected young actors who had never worked in the professional Yiddish theatre and were thus uncontaminated not only by its political associations, but also by what was perceived as its clumsy and naive realism. Only the fact that the actors spoke Yiddish would distinguish them from their non-Jewish counterparts – just as it was now maintained that all that distinguished Soviet citizens who happened to be Jewish from their non-Jewish comrades was the language in which they communicated.

For his first production, Granovsky chose to present Maeterlinck's *The Blind*, a Symbolist play with no Jewish associations whatsoever, translated from French into Yiddish. The manifesto that accompanied this production explained his position: 'We hold that the Yiddish theatre is first of all a theatre in general, a temple of light and beauty and creativity, a temple where prayers are raised in the Yiddish language … . The duty of our theatre … is the duty of world theatre. Only the language differentiates us from the others … .' The same manifesto, however, also asked: 'What will our theatre be like? What gods will it serve? That we cannot answer. We don't know our gods … . We are looking for them … And that is our programme.'

In fact, it soon became apparent, when the theatre moved to Moscow in 1920, that it was to the previously derided traditions of pre-Revolutionary Yiddish literature (not only plays, but also short stories adapted for the stage) that the State Yiddish Theatre would have to turn for inspiration after all – even if the original intentions of the texts were utterly distorted in order to stress the ideals of the Revolution. Granovsky put increasing emphasis on the overall look of the production, on costumes and body movements at the expense of the dialogue. Thus, in his 1922 production of Goldfaden's *The Sorceress*, the original play was adapted to convey a conflict of ideas between the old and new ways, rather than a conflict between or within characters. The original third scene, for instance, took place in the *shtetl* marketplace, into which Granovsky inserted a mock funeral procession to celebrate the death of the old Yiddish Theatre. Similarly, when the witch of the title casts a magic spell, the scene becomes a parody of Kol Nidre, the most solemn of all Jewish prayers.

Generally speaking, GOSEKT's most successful and characteristic productions – the Sholem Aleichem evening designed by Chagall, *The Sorceress* (designed by Isaak Rabinovich), *The Big Win (or The Two Hundred Thousand)* by Sholem Aleichem

(designed by Isaak Rabichev) and *Night in the Old Marketplace*, based on a poem by Peretz with designs by Robert Falk – combined strikingly reductive, Constructivist-inspired set design with an exaggerated, almost expressionistic acting style. Chagall's designs had a far-reaching influence, not only on other artists working for the theatre such as Falk, Rabinovich and Rabichev, but also on the acting style of the entire troupe. By the second half of the 1920s, however, the creative indignation that had fuelled the earlier productions was fading, to be replaced – due largely to the beginnings of disillusionment with the Communist regime – by a greater sympathy for the original texts and the values for which they stood.

In 1927–28, GOSET as it was now called went on a triumphant tour of France, Germany, Holland, Belgium and Austria, but Granovsky's decision to remain in the West dealt the company a mortal blow. This, combined with Stalin's increasingly repressive cultural policies, led to a fatal loss of ideological certainty. Although the theatre continued to exist until 1949, and even managed to score a few successes with the authorities (notably with its production of *King Lear* in 1935), suitable plays were becoming harder and harder to find, and the company found itself increasingly criticised and controlled by the Stalinist regime. By 1950, Mikhoels and Zuskin, the leading actors of GOSET, had been brutally murdered; and the doors of the Moscow State Yiddish Theatre had been locked for ever.

Elsewhere, it is true, the Yiddish theatre lived on, albeit in a modified form. Ever since the 1880s, with the mass emigration of Jews from Russia and eastern Europe to the West prompted by the pogroms of that period, Yiddish culture had put down fresh roots, and new theatre companies had been established, most notably in London, Paris and New York. Distanced both geographically and psychologically from their countries of origin, they portrayed the Jewish world they had left behind in an increasingly rosy and nostalgic light – never more so than after the destruction wrought by the Nazi Holocaust became common knowledge. Similarly, in Chagall's later oeuvre, there are frequent references to motifs first employed so memorably in his murals for the Yiddish theatre; but with time, these too – perhaps inevitably – lose their original conviction, vigour and intensity.

Further Reading

Ruth Apter-Gabriel (ed.), *Tradition and Revolution, The Jewish Renaissance in Russian Avant-Garde Art 1912–1928*, exh. cat., Israel Museum, Jerusalem, 1987

Ken Frieden, *Classic Yiddish Fiction: Abramovitsh, Sholem Aleichem and Peretz*, New York, 1995

Susan Goodman (ed.), *Russian-Jewish Artists in a Century of Change 1890–1980*, exh.cat., Jewish Museum, New York, 1995–96

Avram Kampf, *Chagall to Kitaj: Jewish Experience in 20th Century Art*, exh. cat., Barbican Art Gallery, London, 1990

Joseph C. Landis (trans.), *The Great Yiddish Plays*, New York, 1980

Nahma Sandrow, *Vagabond Stars: A World History of Yiddish Theater*, New York, Hagerstown, San Francisco and London, 1977

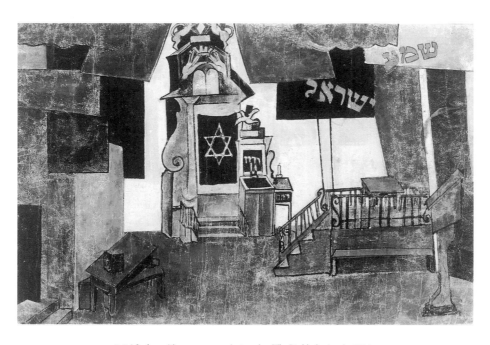

28. Nathan Altman, stage design for *The Dybbuk*, Act I, 1920,
Collection Habima Theatre, Tel Aviv, on loan to The Tel Aviv Museum of Art

Catalogue

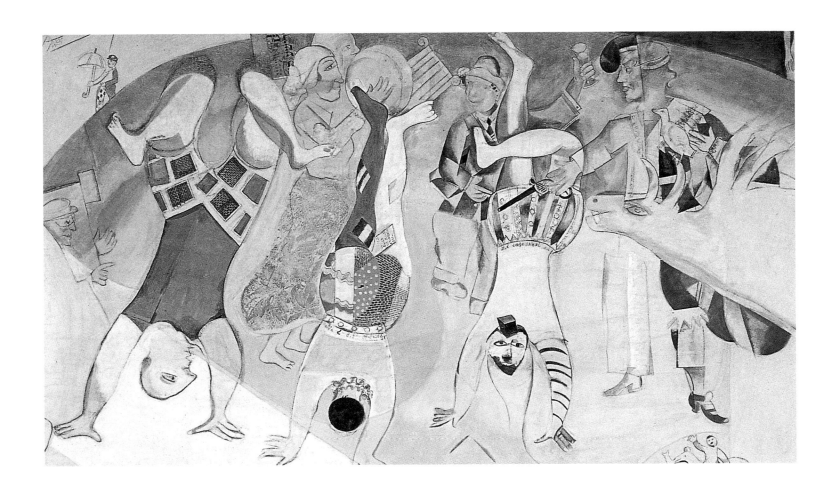

Detail from *Introduction to the Jewish Theatre*, cat. 31

Views of Vitebsk
(cat. 2–13)

Lovers
(cat. 14–23)

Religious paintings
(cat. 24–26)

Banners for Vitebsk
(cat. 27–28)

The State Jewish Chamber Theatre
(cat. 29–38)

Costume and set designers
(cat. 39–55)

Black and white drawings
(cat. 56–59)

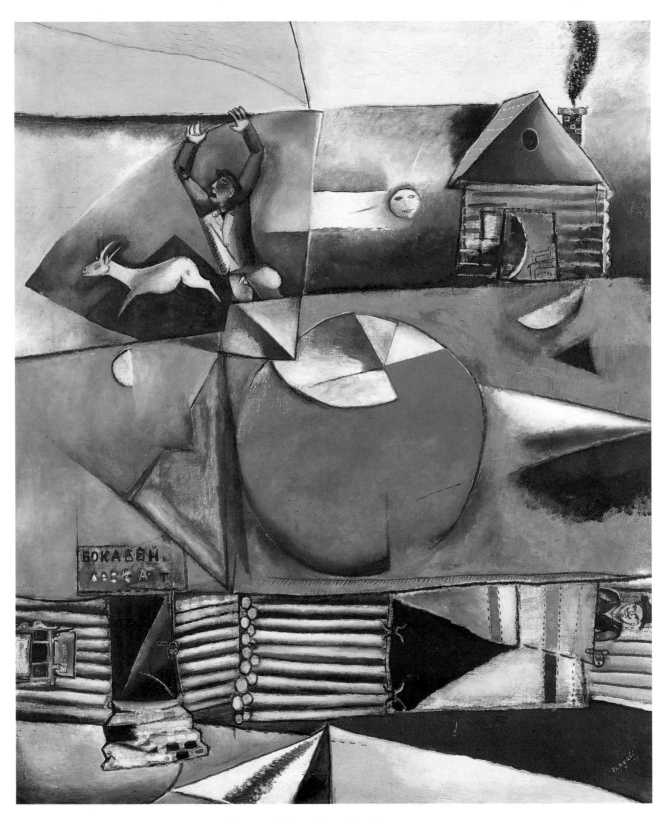

1 Russian Village, from the Moon, 1911–12

oil on canvas, 126 × 104 cm, Private Collection, on loan to the Bayerische Staatsgemäldesammlungen, Munich

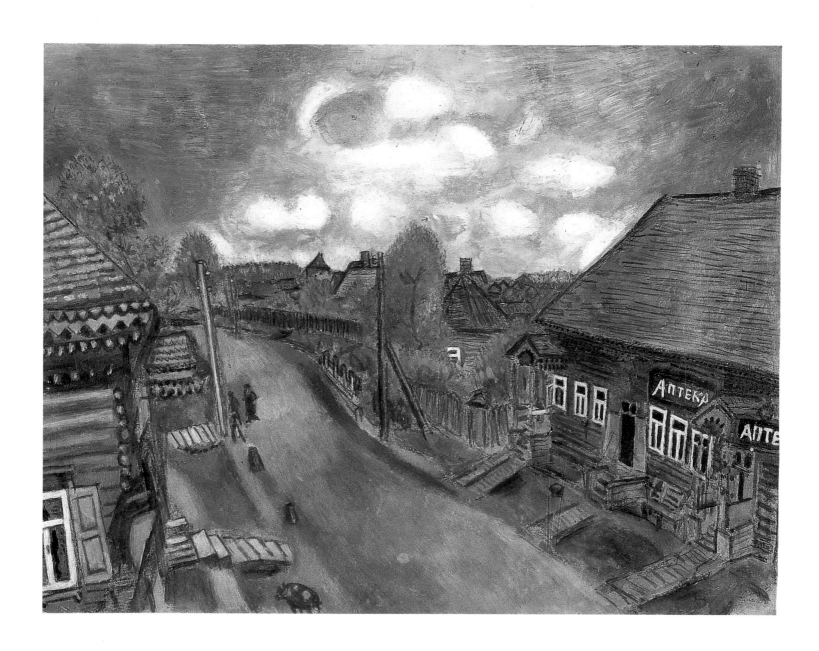

2 Street in Vitebsk, 1914
gouache, oil, pencil, on paper, 40 × 52.4 cm, Private Collection, Moscow

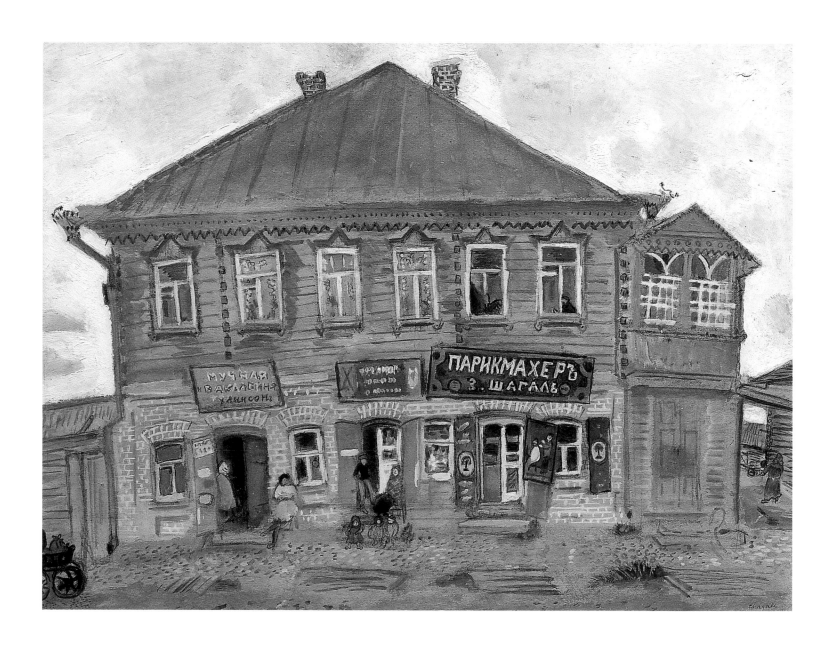

3 Uncle's Store in Liozno, 1914
gouache, oil, pencil on paper, 37.1 × 49 cm, State Tretiakov Gallery, Moscow

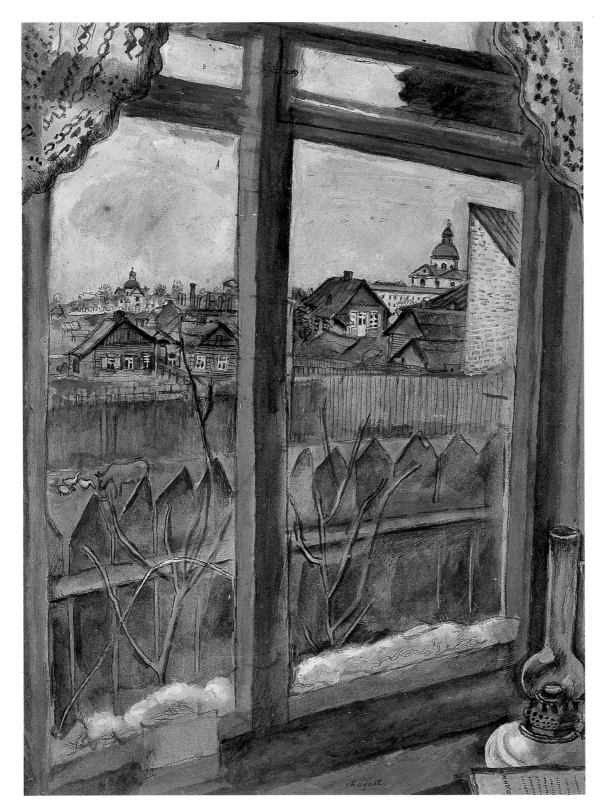

4 View from the Window, Vitebsk, 1914–15

gouache, oil and pencil on paper on cardboard, 49 × 36.3 cm, State Tretiakov Gallery, Moscow

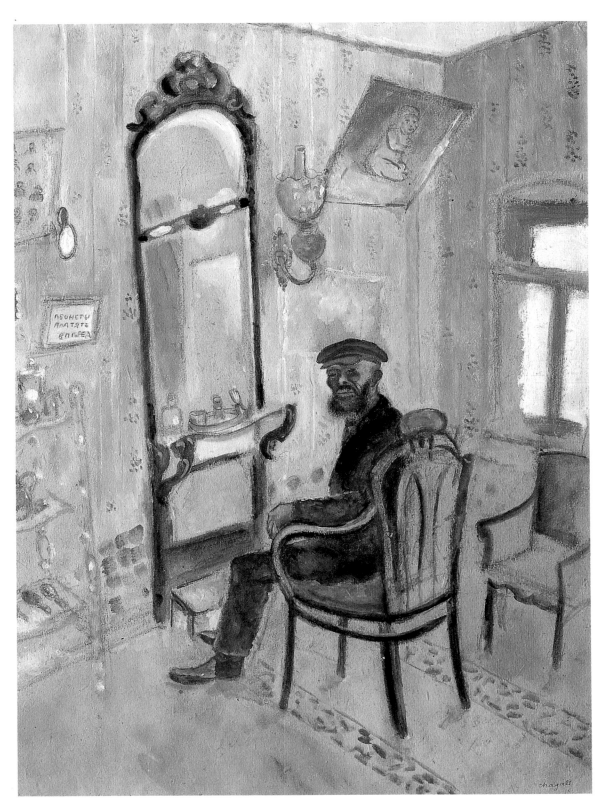

5 Uncle Zussy, The Barber's Shop, 1914
gouache and oil on paper, 49.3 × 37.2 cm, State Tretiakov Gallery, Moscow

6 The Village Idiot, 1914–15
oil and pencil on paper, 49.5 × 37.8 cm, The Metropolitan Museum of Art, New York

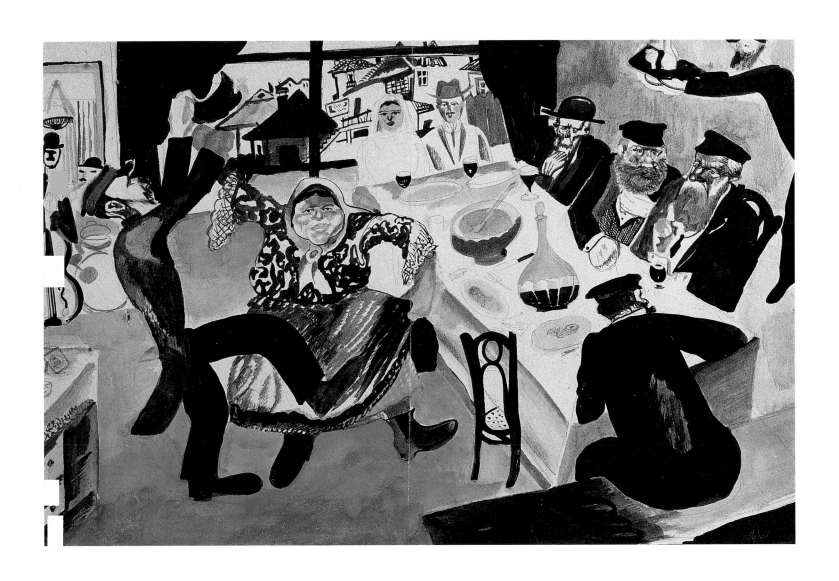

7 The Jewish Wedding, after 1910
gouache, indian ink, pen and brush on paper, mounted on cardboard, 20.5 × 30 cm, Private Collection, St Petersburg

8 Lilies of the Valley, 1916

oil on millboard, 40.8 × 32.1 cm, State Tretiakov Gallery, Moscow

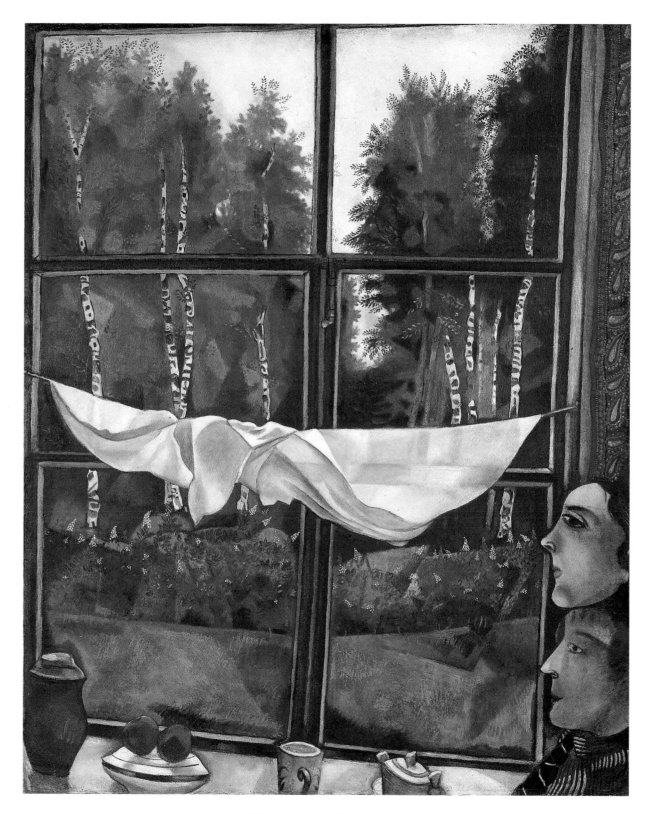

9 Window in the Country, 1915

gouache, oil on millboard, 100.2 × 80.3 cm, State Tretiakov Gallery, Moscow

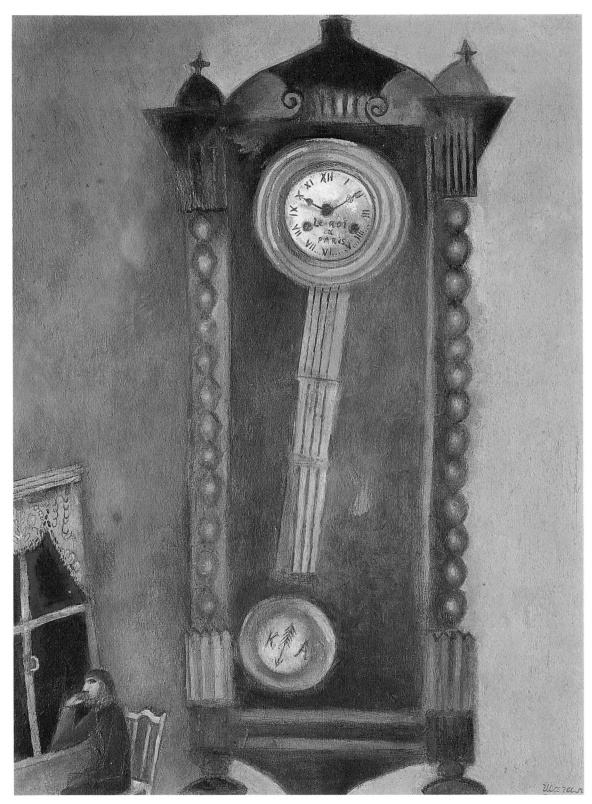

10 Clock, 1914
gouache, oil and pencil on grey paper, 49 × 37 cm, State Tretiakov Gallery, Moscow

11 The Mirror, 1915
oil on millboard, 100 × 81 cm, The State Russian Museum, St Petersburg

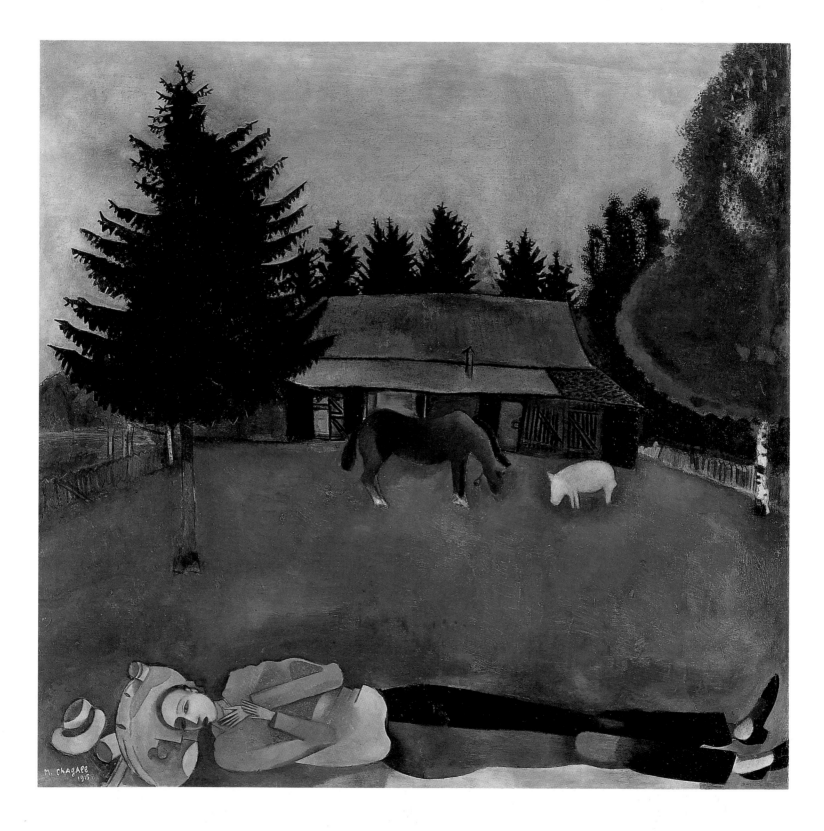

12 The Poet reclining, 1915
oil on millboard, 77 × 77.5 cm, Tate Gallery, London

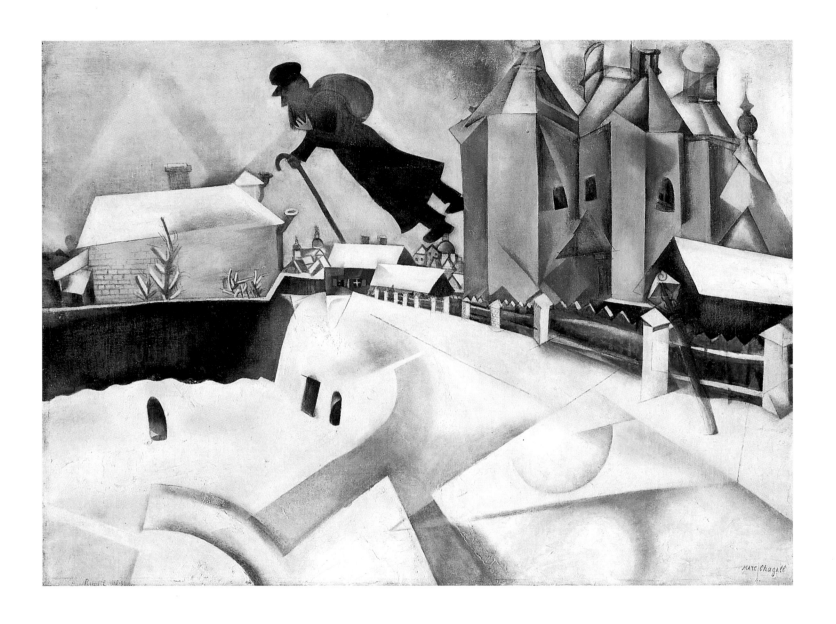

13 Over Vitebsk, 1915–20
oil on canvas, 67 × 92.7 cm, The Museum of Modern Art, New York

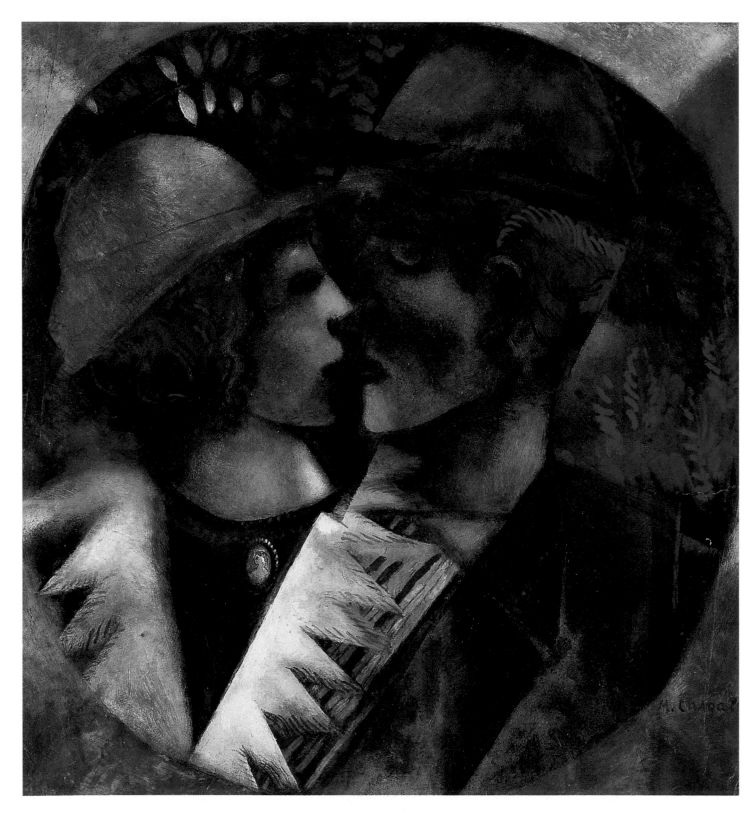

14 Lovers in Green, 1914–15
gouache, oil on paper, mounted on cardboard, 48 × 45.5 cm, Private Collection, Moscow

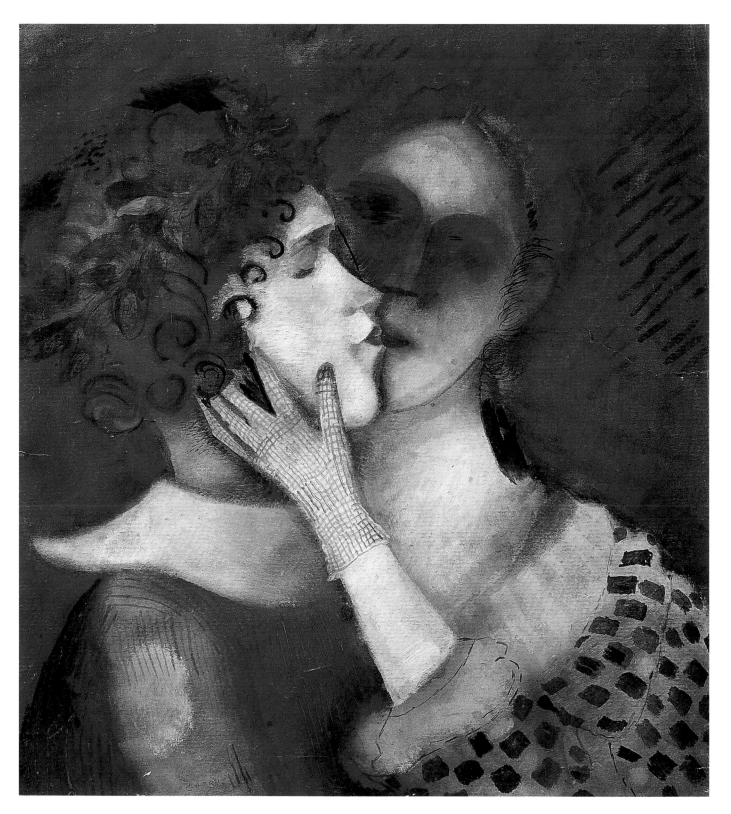

15 Lovers in Blue, 1914

gouache and pastel on paper, mounted on cardboard, 49 × 44 cm, Private Collection, St Petersburg

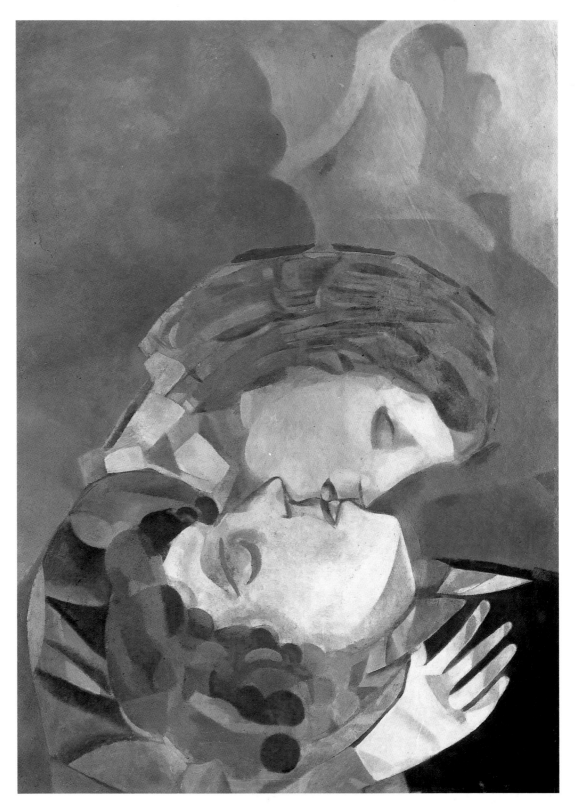

16 Pair of Lovers, 1916
oil on millboard, 70.7 × 50 cm, Private Collection

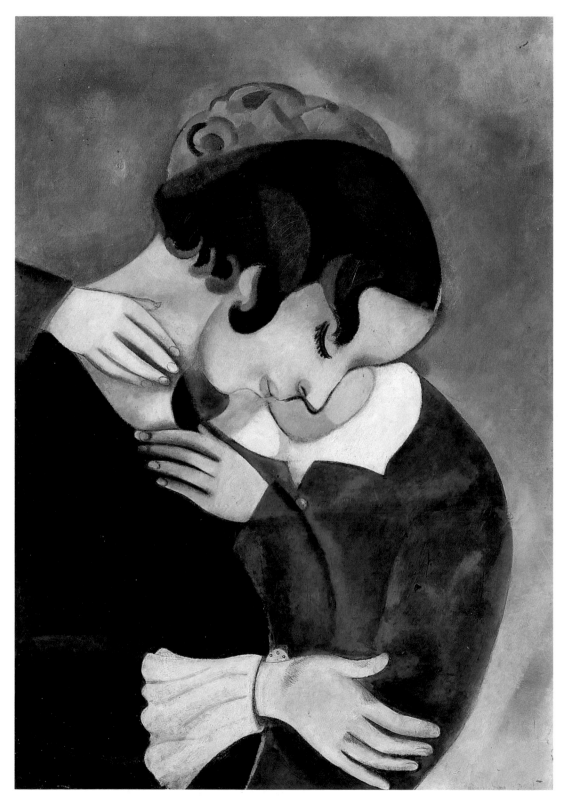

17 Lovers in Pink, 1916
oil on millboard, 69 × 55 cm, Private Collection, St Petersburg

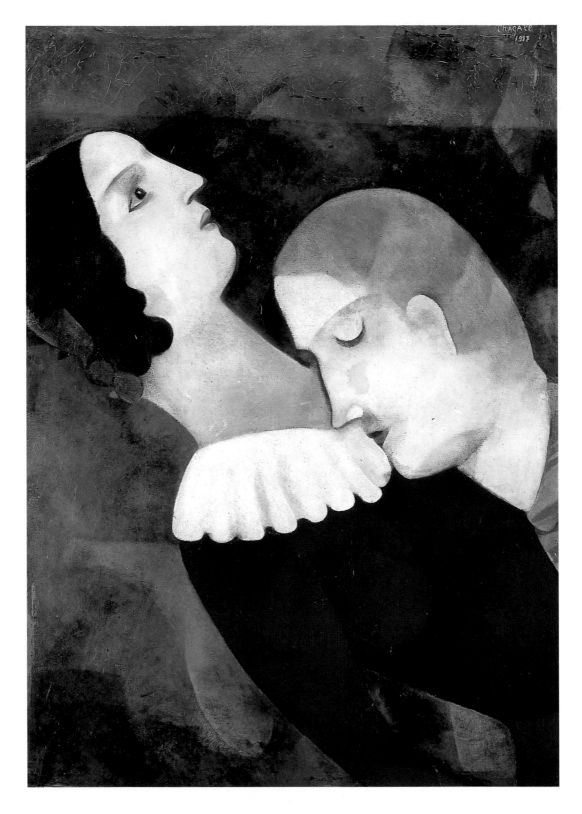

18 Lovers in Green, 1916–17
oil on cardboard, laid on canvas, 69.7 × 49.5 cm, Musée national d'art moderne, Paris

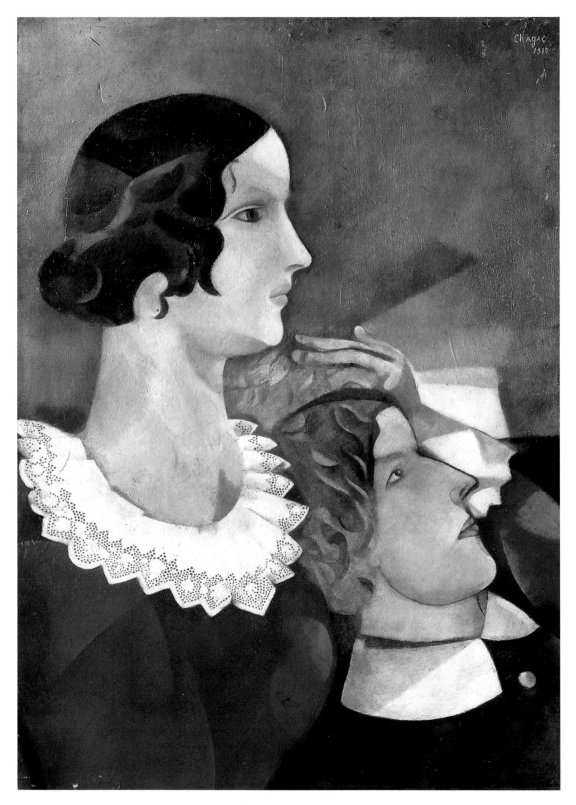

19 Lovers in Grey, 1916—17
oil on cardboard, laid on canvas, 69 × 49 cm, Musée national d'art moderne, Paris

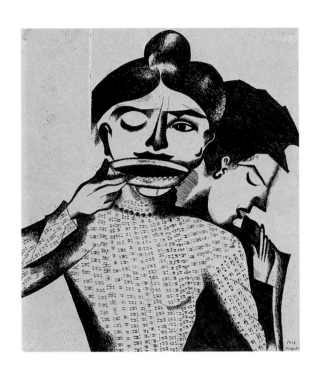

20 Woman drinking from a Saucer, 1918
black ink on paper, 21.4 × 18.5 cm, Musée national d'art moderne, Paris

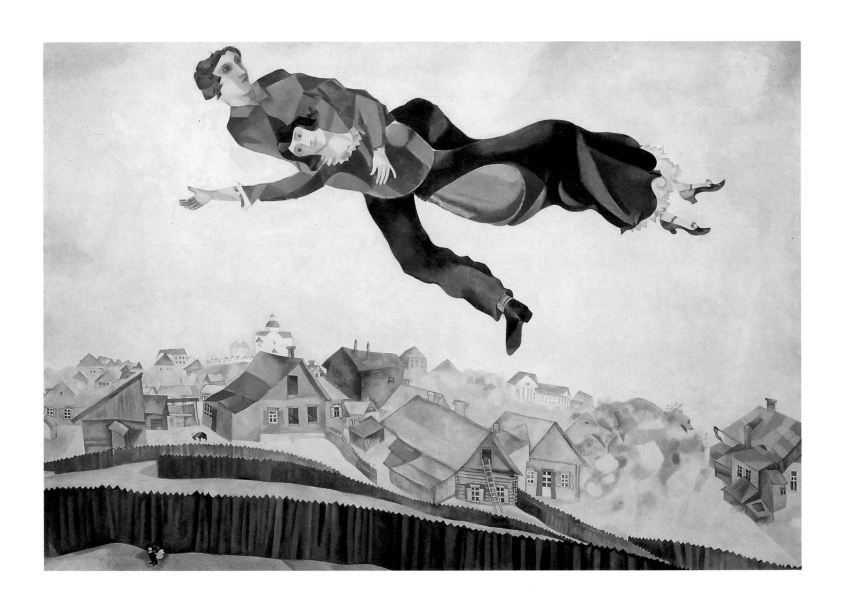

21 Over the Town, 1914–18
oil on canvas, 141 × 198 cm, State Tretiakov Gallery, Moscow

22 Lovers in Black, after 1910
indian ink, pen and pencil on paper, 23 × 18 cm, Museum of History, Art and Architecture, Pskov

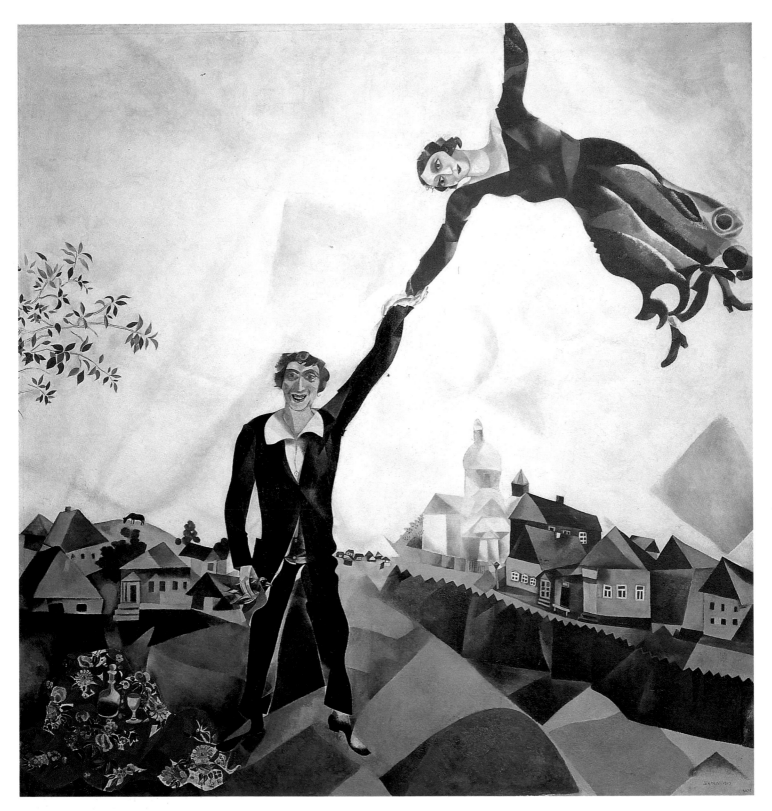

23 Promenade, 1917–18

oil on canvas, 170 × 163.5 cm, The State Russian Museum, St Petersburg

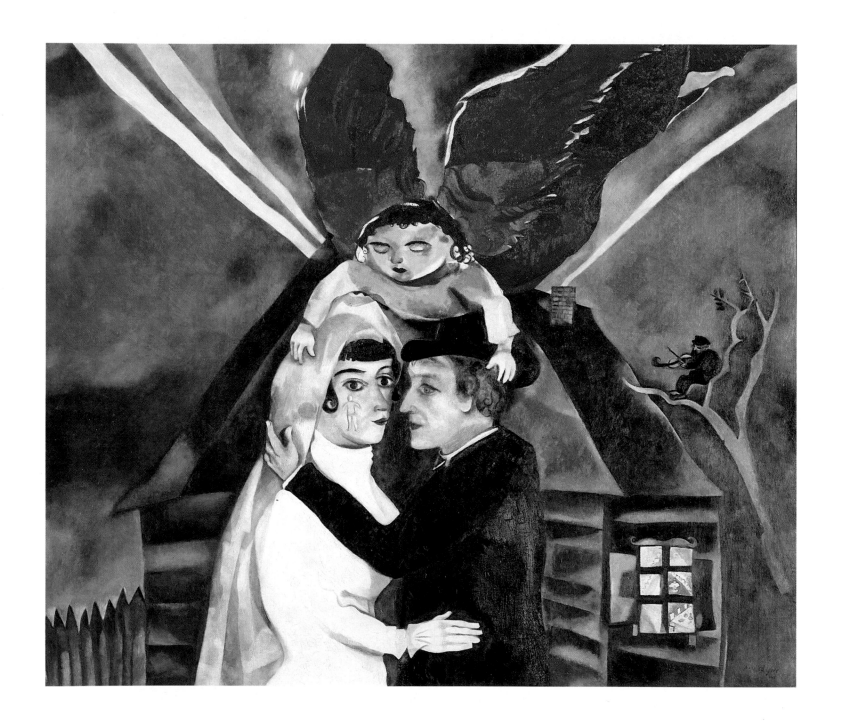

24 Wedding, 1918
oil on canvas, 100 × 119 cm, State Tretiakov Gallery, Moscow

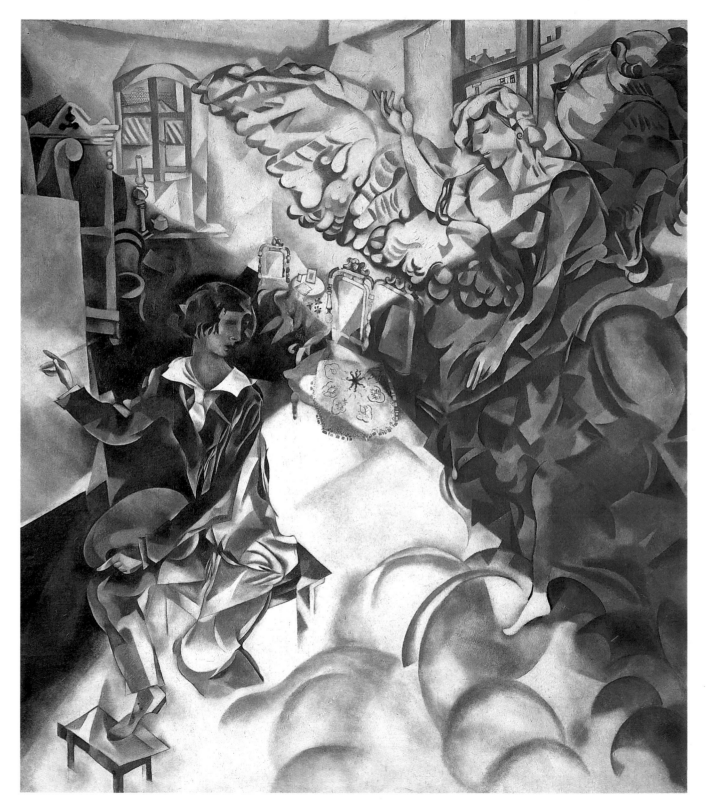

25 The Apparition, 1917–18
oil on canvas, 157 × 140 cm, Private Collection, St Petersburg

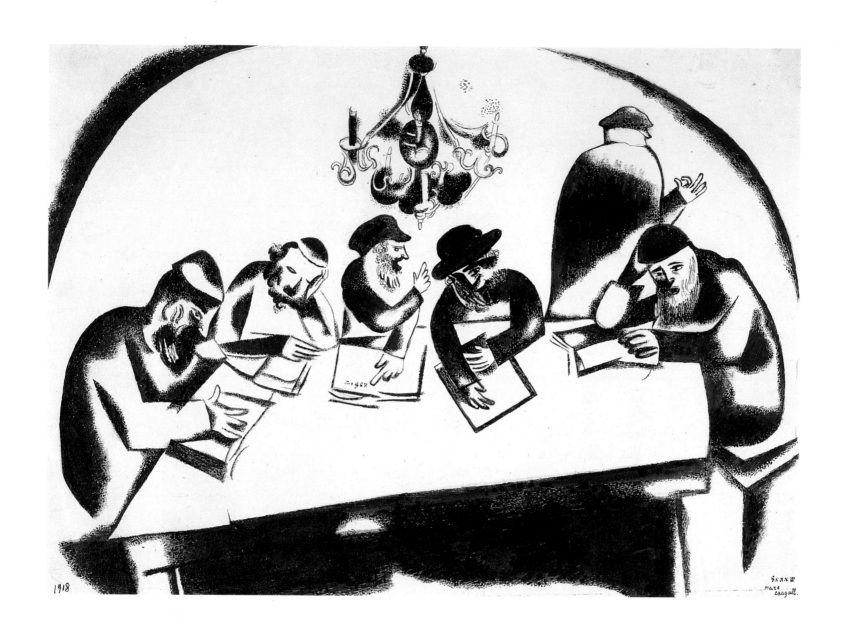

26 Study, 1918

black ink on cream paper, 24.9 × 34.3 cm, Musée national d'art moderne, Paris

27 Peace to Huts – War on Palaces, 1918
watercolour, indian ink and pencil on paper, 33.7 × 23.2 cm
State Tretiakov Gallery, Moscow

28 The Rider, 1918
pencil and gouache on paper, 23 × 30 cm,
Private Collection

The State Jewish Chamber Theatre

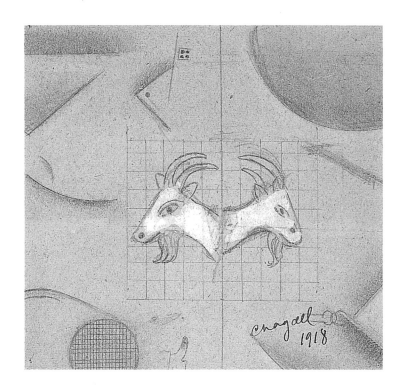

29 Design for the Curtain of The State Jewish Chamber Theatre
watercolour on buff paper, 14 × 14.9 cm, Private Collection

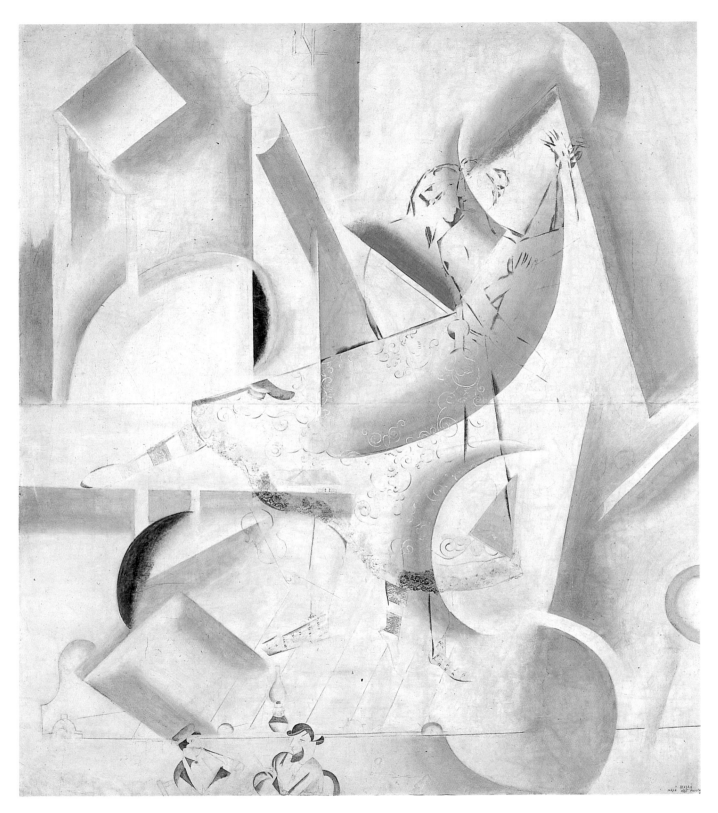

30 Love on the Stage, 1920
tempera, gouache and opaque white on canvas, 283 × 248 cm, State Tretiakov Gallery, Moscow

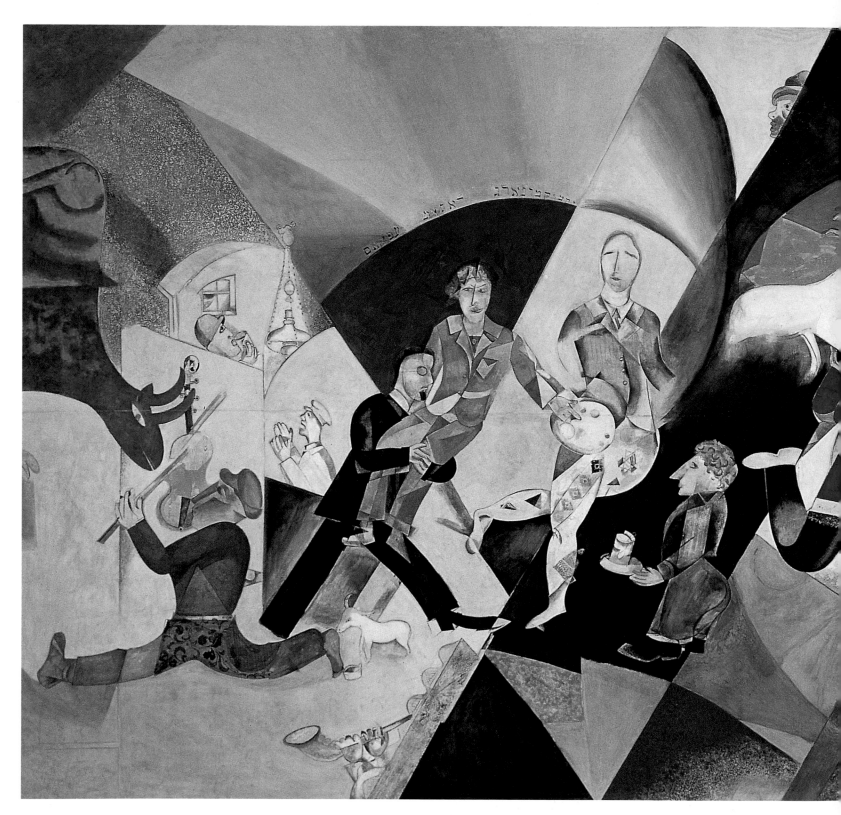

31 Introduction to the Jewish Theatre, 1920
tempera, gouache and opaque white on canvas, 284 × 787 cm, State Tretiakov Gallery, Moscow

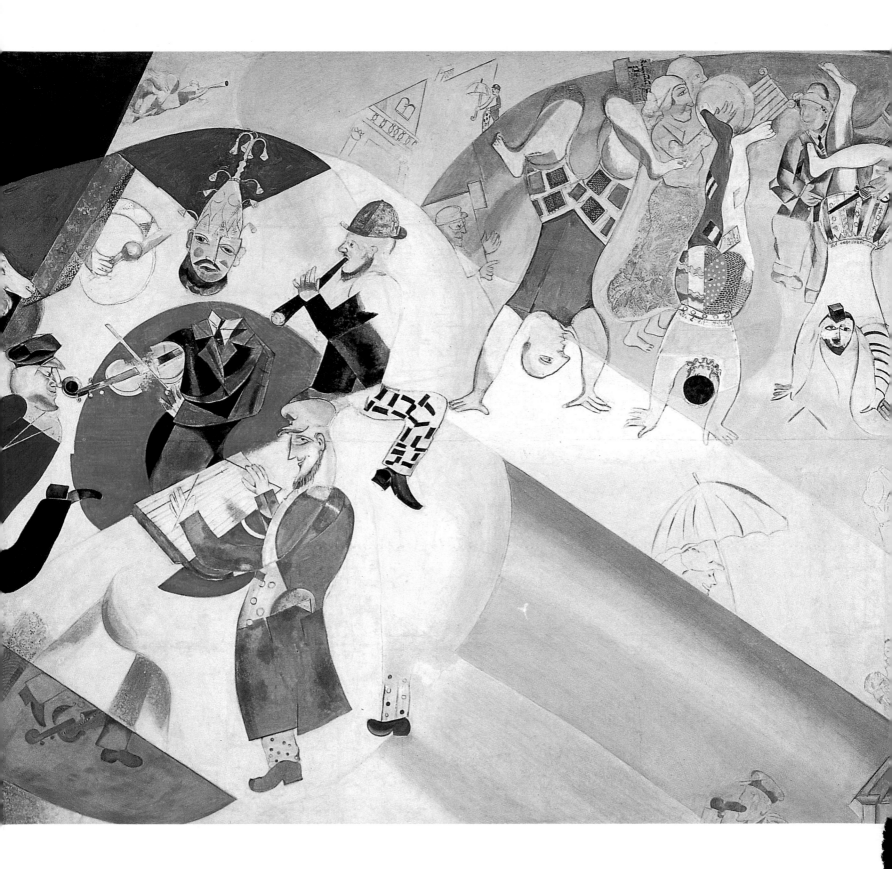

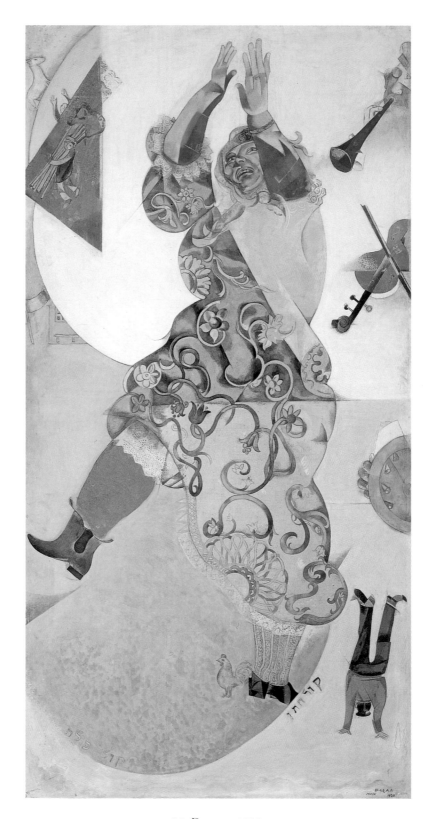

33 Dance, 1920
tempera, gouache and opaque white on canvas, 214 × 108.5 cm, State Tretiakov Gallery, Moscow

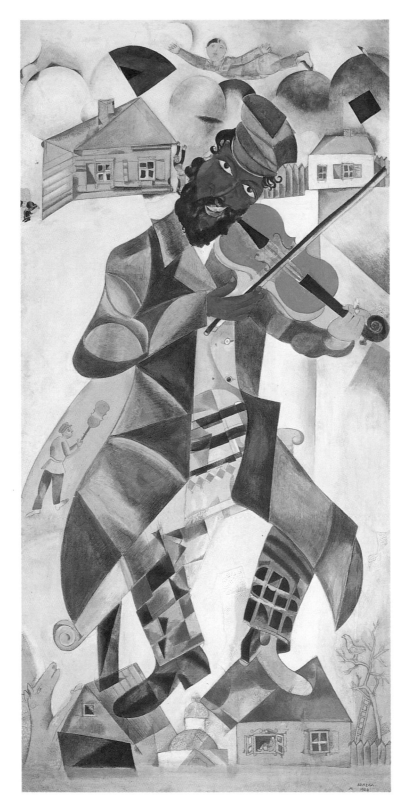

32 Music, 1920
tempera, gouache and opaque white on canvas, 213 × 104 cm, State Tretiakov Gallery, Moscow

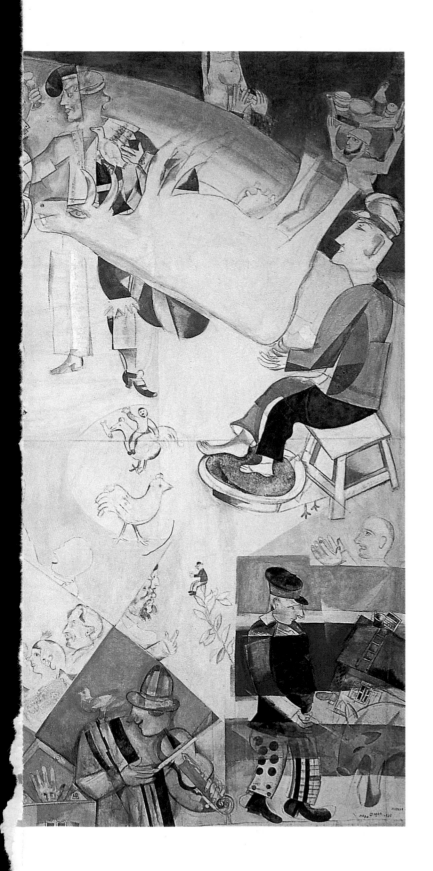

36 The Wedding Feast, 1920
tempera, gouache and opaque white on canvas, 64 × 799 cm, State Tretiakov Gallery, Moscow

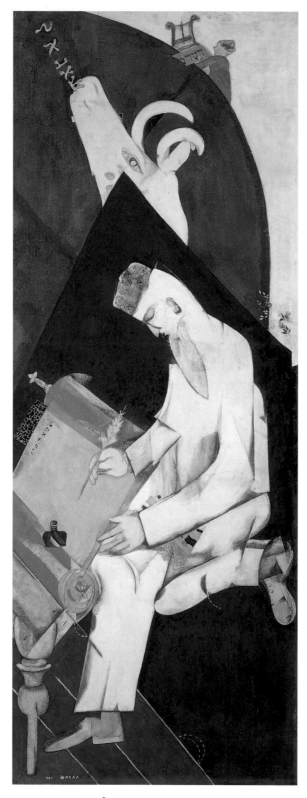

35 Literature, 1920
tempera, gouache and opaque white on canvas, 216 × 81.3 cm, State Tretiakov Gallery, Moscow

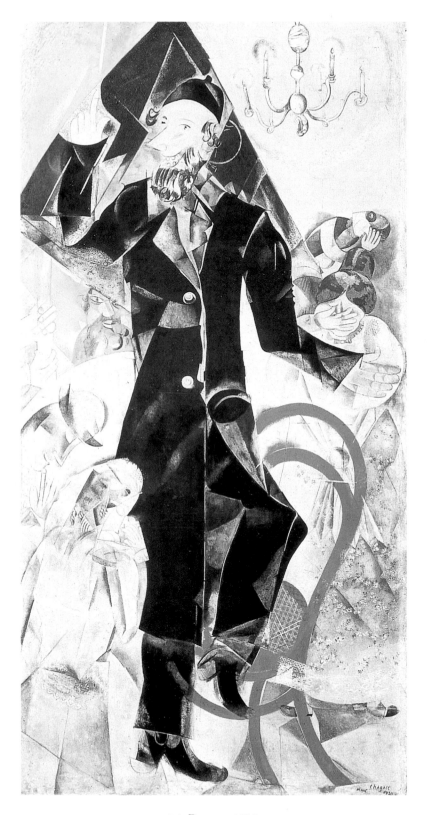

34 Drama, 1920
tempera, gouache and opaque white on canvas, 212.6 × 107.2 cm, State Tretiakov Gallery, Moscow

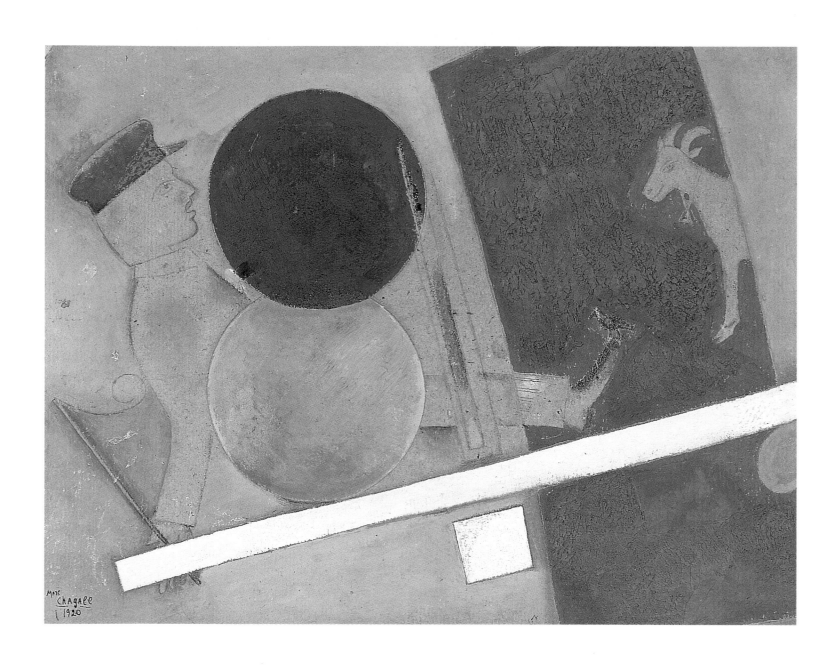

37 Composition with Circles and Goat, 1920
oil on cardboard, 38 × 49.5 cm, Private Collection

38 Study for Introduction to the Jewish Theatre, 1920
watercolour, gouache and oil on cardboard, 35.5 × 17.4 cm, Private Collection

Mazeltov

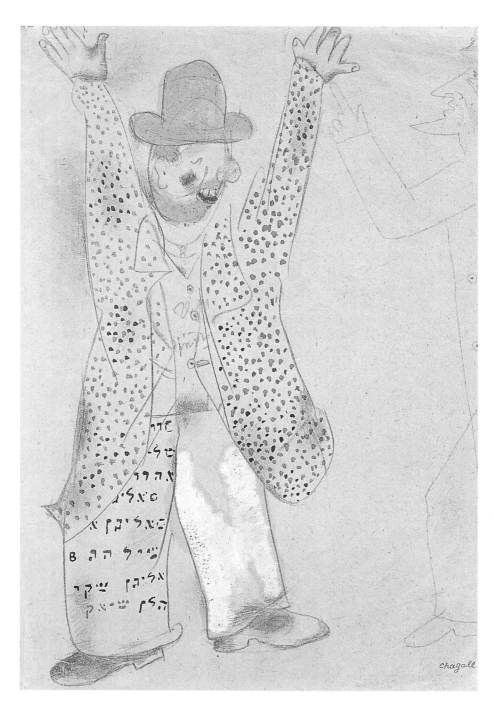

39 Costume design for *Mazeltov* by Sholem Aleichem: Man's Costume, 1920
pencil, gouache and ink on buff paper, 27 × 19.3 cm,
Private Collection

40 Sketch for the stage set of *Mazeltov*, 1920
pencil and watercolour on paper, 25.5 × 34.5 cm, Private Collection

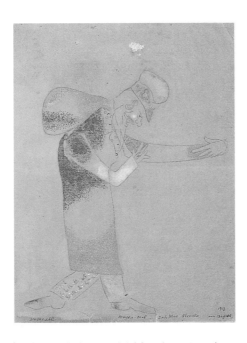

41 The Actor Solomon Mikhoels in *Mazeltov*, 1920
pencil and watercolour on buff paper, 36 × 26.3 cm,
Private Collection

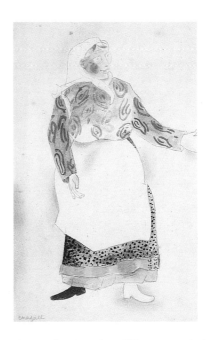

42 Costume design for *Mazeltov*: Woman with Apron, 1920
ink and watercolour on paper, 28.1 × 12.7 cm,
Private Collection

The Agents

43 Sketch for the stage set of *The Agents* by Sholem Aleichem, 1919–20
pencil, gouache and ink on cream paper, 25.6 × 34.2 cm, Musée national d'art moderne, Paris

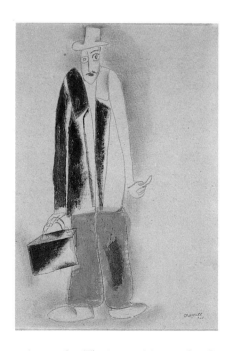

44 Costume design for *The Agents*: Man with a Suitcase, 1920
pencil, black ink and gouache on beige paper, 27.4 × 20.3 cm,
Musée national d'art moderne, Paris

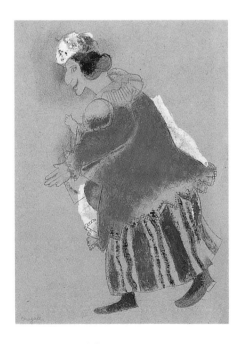

45 Costume design for *The Agents*: Woman with Child, 1920
pencil and gouache on beige paper, 27.7 × 20.3 cm,
Private Collection

It's a Lie

46 Sketch for the stage set of *It's a Lie* by Sholem Aleichem, 1920
pencil and gouache on paper, 22.5 × 30 cm, Private Collection

47 Costume design for the Actor Solomon Mikhoels, 1920
pencil and watercolour on paper, 22.5 × 30 cm,
Private Collection

48 Costume design for *It's a Lie*: Man with Long Nose, 1920
pencil, black ink and gouache on beige paper, 26 × 18 cm,
Private Collection

Comrade Khlestakov

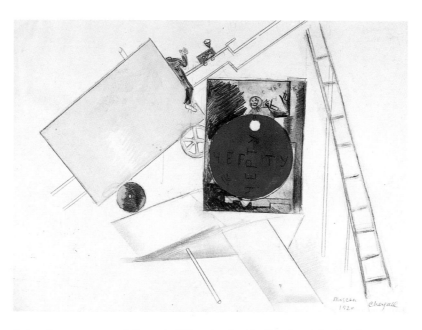

49 Sketch for the stage set of *Comrade Khlestakov* by D. Smolin: The Little Train (ii), 1921
pencil, black ink, gouache and watercolour on paper, 28.5 × 34.4 cm, Musée national d'art moderne, Paris

50 Costume design for Bobchinsky-Dobchinsky
in *Comrade Khlestakov*, 1921
watercolour and pencil on paper, 27.2 × 19.2 cm, Private Collection

51 Costume design for Svistunov in
Comrade Khlestakov, 1921
watercolour and pencil on paper, 27.2 × 19.2 cm, Private Collection

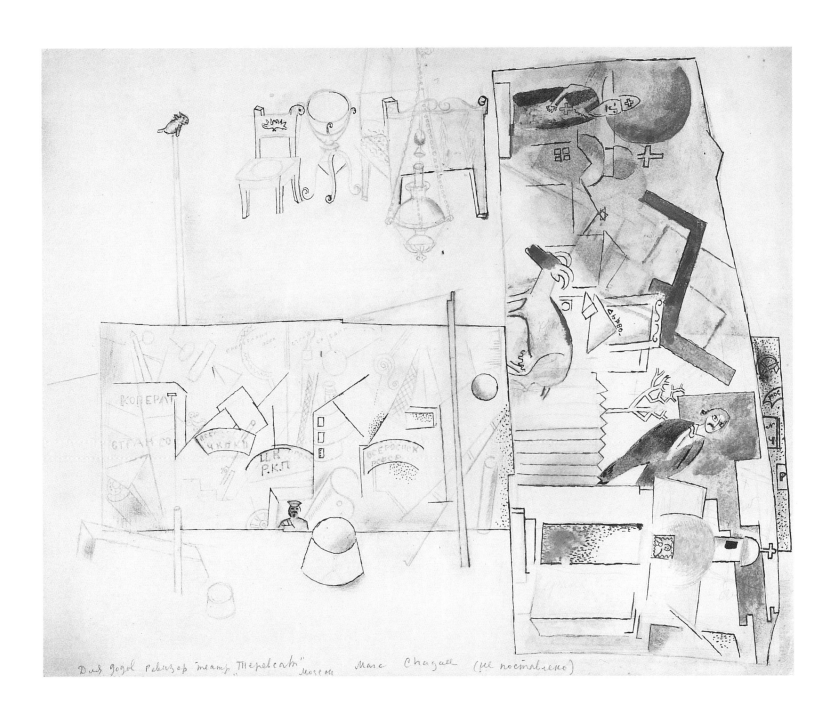

Дъвъ gogol revizor театр "Перевали" moscou Marc Chagall (не поставлено)

52 Sketch for the stage set of *Comrade Khlestakov: The Little Goat*, 1921
pencil, black ink, gouache and watercolour on paper, 29.2 × 35.6 cm, Musée national d'art moderne, Paris

Playboy of the Western World

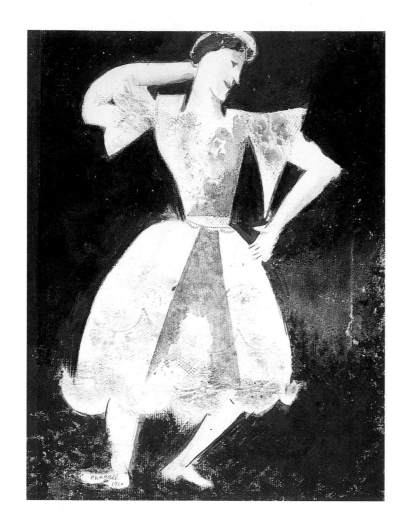

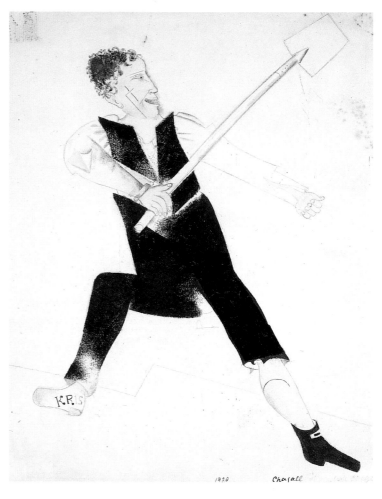

53 Costume design for *The Playboy of the Western World*
by J.M. Synge: Young Girl, 1921

watercolour (lace imprint), pencil, gouache, black ink with gold highlights
on paper, 32.8 × 25.9 cm, Musée national d'art moderne, Paris

54 Costume design for *The Playboy of the Western World*:
Kris, 1921

black ink, varnish, pencil, gouache and watercolour on cream paper,
32.8 × 25.9 cm, Musée national d'art moderne, Paris

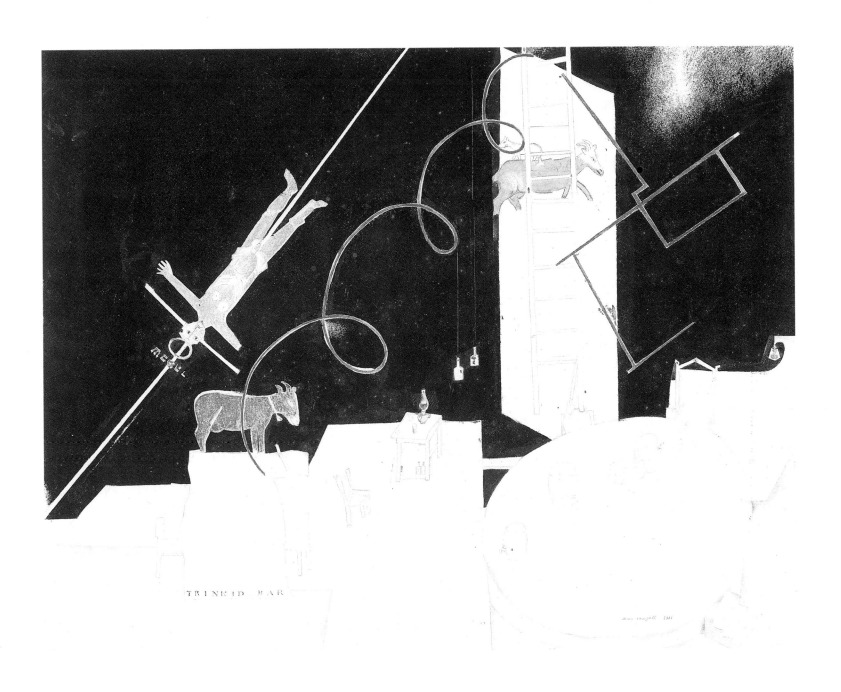

55 Sketch for the stage set of *The Playboy of the Western World*, 1921
pencil, black ink, gouache, gold and silver paint on paper, 40.7 × 51.1 cm, Musée national d'art moderne, Paris

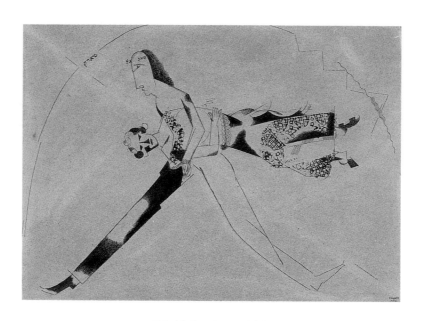

56 Abduction, 1920
black ink on grey paper, 34 × 47.1 cm,
Musée national d'art moderne, Paris

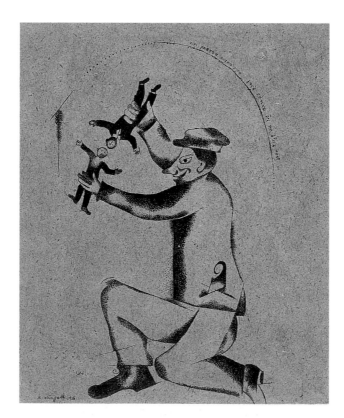

57 Man with Marionettes, 1916
black ink on brown wrapping paper, 25.7 × 21.4 cm,
Musée national d'art moderne, Paris

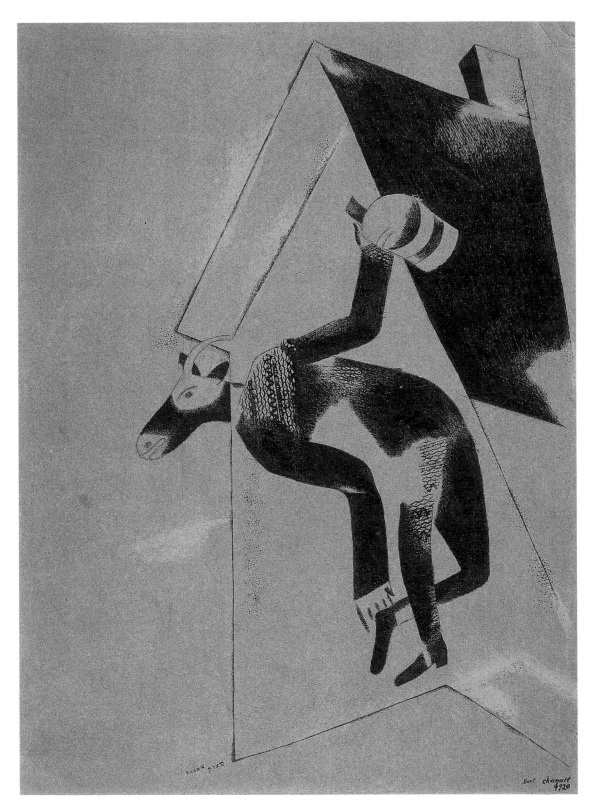

58 With a Bucket, 1920
pen and black ink on grey paper, 46.7 × 34 cm, Musée national d'art moderne, Paris

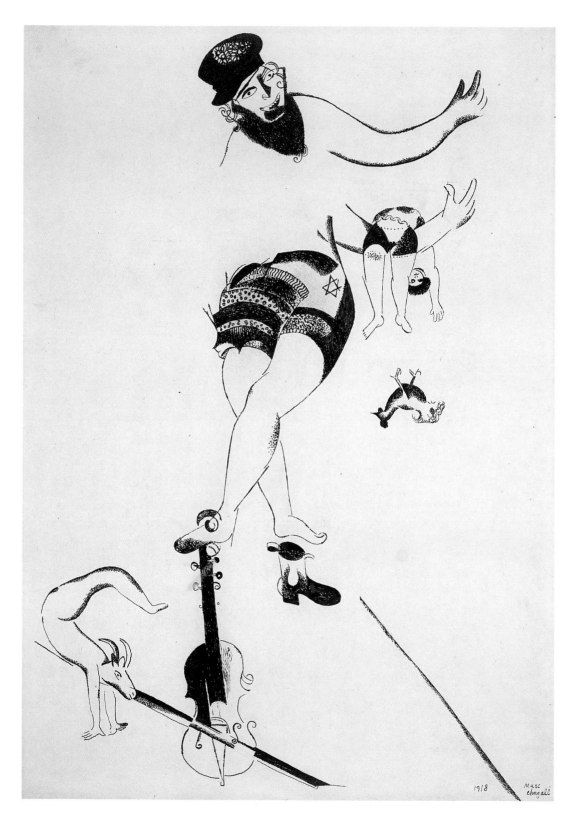

59 Acrobat, 1918
black ink and red chalk on a leaf of wove paper, 32.4 × 22.4 cm, Musée national d'art moderne, Paris

List of Works

Marc Chagall had arrived to study in Paris late in 1910 after studying for four years in St Petersburg. His first-hand experience of the work of some of the most advanced avant-garde artists, and his friendship with the Russian Sonia Delaunay, her husband Robert, their friend the Russian-speaking poet, Blaise Cendrars, and Guillaume Apollinaire (who also spoke Russian) inevitably shaped his own originality. He tried out different styles in large-scale paintings and, by spring 1914, when he was offered a personal exhibition by Herwarth Walden at his gallery, Der Sturm, Chagall had painted such original work as *Russian Village from the Moon* [1]. In his imaginary view of this world from outer space Chagall seems to pun on the Moon as planet and as a seat of Love, for the disk-shaped, red 'world' at the centre of the picture doubles as a human heart, around which the external and internal worlds of the artist pulsate. This representative of Chagall's Paris pictures makes an excellent introduction, for some of its features anticipate his *Introduction to the Jewish Theatre* [31] with its strong central circular forms and its many small anecdotal scenes.

1.

Russian Village, from the Moon

1911–12
oil on canvas, 126 × 104 cm
Private Collection, on loan to the Bayerische Staatsgemäldesammlungen, Munich, Staatsgalerie moderner Kunst (L.1439)

Views of Vitebsk

In Vitebsk, Chagall did not remain cut off from the Russian avant-garde; he contributed twenty-four pictures to the exhibition 'The Year 1915', held in Moscow in April 1915. His fellow exhibitors included the Jewish artists Nathan Altman and Robert Falk, as well as members of the Moscow Futurist avant-garde – Mikhail Larionov, Natalia Goncharova, Aleksandra Ekster, David Burliuk, and the older Vasily Kandinsky, who was already pursuing his own route towards abstraction. Titles for Chagall's paintings recorded in the catalogue include: cat. 210, *Barber's Shop* [5], cat. 191, *Clock* [10] and cat. 189, *Black and White* (usually thought to be *Praying Jew* [fig.16]; four pictures (cat. 202–206) under the heading 'Vitebsk Landscapes' may have included [2], [3], [4].

2.

Street in Vitebsk

1914
gouache, oil, pencil, on paper, 40 × 52.4 cm
Private Collection, Moscow

Exhibited at the 'Knave of Diamonds', Moscow, November 1916, cat. 369 (*Apteka v m. Liozne; Pharmacy in the suburb of Liozno*).

3.

Uncle's Store in Liozno

1914
gouache, oil, pencil on paper, 37.1 × 49 cm
State Tretiakov Gallery, Moscow, inv. 22893

Russian title: *Dom v mestechke Liozno* (*House in the suburb of Liozno*)
Acquired in 1936.

4.

View from the Window, Vitebsk

1914–15
gouache, oil and pencil on paper on cardboard, 49 × 36.3 cm
State Tretiakov Gallery, Moscow, inv. 22894

Acquired from the State Museum of Modern Western Art in 1936.
Exhibited at the 'Knave of Diamonds', Moscow, November 1916, cat. 366.

5.

Uncle Zussy, The Barber's Shop

1914
gouache and oil on paper, 49.3 × 37.2 cm
State Tretiakov Gallery, Moscow, inv. 17334

Russian title: *Parikmakherskaia. (Hairdresser)*
Acquired from the State Museum of Modern Western Art (formerly collection of I.A. Morozov) in 1928.
Exhibited at 'The Year 1915' Moscow, April 1915, cat. 210.

6.

The Village Idiot

1914–15
oil and pencil on paper, 49.5 × 37.8 cm
The Metropolitan Museum of Art, New York, Bequest of Scofield Thayer, 1982

Formerly on loan to the Worcester Art Museum, MA

7.

The Jewish Wedding

after 1910
gouache, indian ink, pen and brush on paper, mounted on cardboard, 20.5 × 30 cm
Private Collection, St Petersburg

8.

Lilies of the Valley

1916
oil on millboard, 40.8 × 32.1 cm
State Tretiakov Gallery, Moscow, inv. 46678, Gift of George Costakis, 1977

Acquired by Costakis from Dedenko, Moscow.
Exhibited in Petrograd 1917, 'Studies', cat. 235–241 (*Studies at the Dacha*).

9.

Window in the Country

1915
gouache, oil on millboard, 100.2 × 80.3 cm
State Tretiakov Gallery, Moscow, inv. 9196.

Russian title: *Okno na dache. Zaol'sh'e bliz Vitebska. (Window at the Dacha. Zaolshe near Vitebsk)*
Acquired in 1927 from the GMF [State Museum Archive] previously in the collection of V. Girchman, Moscow.
Exhibited at 'Knave of Diamonds', Moscow, November 1916, cat. 339.

10.
Clock

1914
gouache, oil and pencil on grey paper, 49 × 37 cm
State Tretiakov Gallery, Moscow, inv. 9190

Acquired in 1927 from the GMF [State Museum
Archive] formerly in the collection of
L.S.Gavronskaia.
Exhibited at 'The Year 1915', Moscow, April 1915,
cat.191.

11.
The Mirror

1915
oil on millboard, 100 × 81 cm
The State Russian Museum, St Petersburg,
inv. JB-1707

Acquired in 1926 from the Museum of Art and
Culture.
Exhibited at the 'Knave of Diamonds', Moscow,
November 1916, cat.343; 1917 Petrograd,
cat.244; 1919 Petrograd.

12.
The Poet reclining

1915
oil on millboard, 77 × 77.5 cm
Tate Gallery, London, purchased 1942

Purchased from H.T. de Vere Collection through
the Leicester Galleries (Knapping Fund) 1942;
formerly Roger de La Fresnaye, Paris (c.1924–25);
through Arthur Tooth and Sons, London; H.T.de
Vere Clifton, Lytham, 1937.

According to a label on the back of the painting, it
has been known as 'Evening' and 'The Poet' but
Chagall himself preferred the title *Le Poète allongé*.
Exhibited [presumably at the Dobychina gallery]
1916 Petrograd, cat. 142.

13.
Over Vitebsk

c. 1915–20
oil on canvas, 67 × 92.7 cm
The Museum of Modern Art, New York. Acquired
through the Lillie P. Bliss Bequest, 1949 (277.49)

This is the second finished version of the picture;
the first, painted in 1914 in oil on millboard,
belongs to the Ayala and Sam Zacks Collection.

Lovers

The six pairs of lovers were apparently painted by
the artist for his wife to mark special occasions.
The first two were named in the catalogue of the
'Knave of Diamonds' exhibition, held in Moscow
in November 1916, as *Lovers (green)* and *Lovers
(blue)*. The catalogue of 'Modern Russian Painting',
held at the Dobychina gallery in Petrograd from
10 December 1916 to 14 January 1917, lists four
paintings, cat. 201 a–d, designated 'To my wife'. As
no titles are given, it is not possible to say whether
they were some of the present series.

14.
Lovers in Green

1914–15
gouache, oil on paper, mounted on cardboard,
48 × 45.5 cm
Private Collection, Moscow

This painting originally belonged to Abram Efros.
Exhibited at 'Knave of Diamonds', Moscow,
November 1916, cat. 346.

15.
Lovers in Blue

1914
gouache and pastel on paper, mounted on
cardboard, 49 × 44 cm
Private Collection, St Petersburg

Exhibited at 'Knave of Diamonds', Moscow,
November 1916, cat.347.

16.
Pair of Lovers

1916
oil on millboard, 70.7 × 50 cm
Private Collection

17.
Lovers in Pink

1916
oil on millboard, 69 × 55 cm
Private Collection, St Petersburg

18.
Lovers in Green

1916–17
oil on cardboard, laid on canvas, 69.7 × 49.5 cm
Musée national d'art moderne, Centre Georges
Pompidou, Paris

19.
Lovers in Grey

1916–17
oil on cardboard, laid on canvas, 69 × 49 cm
Musée national d'art moderne, Centre Georges
Pompidou, Paris

20.
Woman drinking from a Saucer

1918
black ink on paper, 21.4 × 18.5 cm
Musée national d'art moderne, Centre Georges
Pompidou, Paris

21.
Over the Town

1914–18
oil on canvas, 141 × 198 cm
State Tretiakov Gallery, Moscow, inv. 11887

Acquired in 1929 from the State Russian Museum,
Leningrad, formerly Museum of Painting, Petrograd.
Exhibited at 'First Free Exhibition', Petrograd,
1919, cat. 1540 (dated 1917).

22.
Lovers in Black

after 1910
indian ink, pen and pencil on paper, 23 × 18 cm
Museum of History, Art and Architecture, Pskov
inv. 1027

Received from Porkhov (bought by the Extramural
Department of National Education in 1925)
Exhibited at 'Pictures by Russian artists', Pskov
1920, cat.187.

23.
Promenade

1917–18
oil on canvas, 170 × 163.5 cm
The State Russian Museum, St Petersburg,
inv. JB-1726

Acquired in 1924 from the State Museum Archives.
Exhibited at 'First Free Exhibition', Petrograd,
1919 (dated 1917).

Religious paintings

Chagall's more specifically religious paintings, such as *Jew in Black and White* (fig.19) and *Jew in Red* (fig.6), are not among those exhibited, though the pen and ink drawing [26] is overtly Jewish, with its group of Rabbis studying texts. Chagall has played with the theme by leaving the pages in front of the scholars nearly blank and making one figure leave the table in disgust. The theatrical gestures suggest that he may have had in mind a play by his friend, S. Ansky - *The Dybbuk* - about a student rabbi who falls in love with his teacher's daughter; the young lovers are denied marriage and, after being forced to marry another, the girl dies of a broken heart and returns to haunt the student. Chagall's later use of wedding characters in the Theatre murals suggests that the play remained in his mind. In contrast, the subject of *Wedding* [24] is himself and Bella, and, with *Apparition* [25], shows another side of Chagall's religious paintings with iconography borrowed from the traditional Christian repertoire (see pp. 22–23). He may have done this to give additional weight to compositions intended for collectors of contemporary Jewish art, aiming by this means to produce an instant historical pedigree for them.

24.
Wedding
1918
oil on canvas, 100 × 119 cm
State Tretiakov Gallery, Moscow, inv. 11888

Acquired from the State Russian Museum, Leningrad, formerly Museum of Painting, Petrograd.
Exhibited at 'First Free Exhibition', Petrograd, 1919, cat.1539 (dated 1917).

25.
The Apparition
1917–18
oil on canvas, 157 × 140 cm
Private Collection, St Petersburg

Exhibited at 'First Free Exhibition', Petrograd 1919, cat.1541 (dated 1917).

26.
Study
1918
black ink on cream paper, 24.9 × 34.3 cm
Musée national d'art moderne, Centre Georges Pompidou, Paris

Banners for Vitebsk

Two squared-up watercolours are designs for banners for the streets of Vitebsk on the occasion of the celebration of the first anniversary of the October Revolution.

27
Peace to Huts – War on Palaces
1918
watercolour, indian ink and pencil on paper, 33.7 × 23.2 cm
State Tretiakov Gallery, Moscow, inv. 22246

28
The Rider
1918
pencil and gouache on paper, 23 × 30 cm
Private Collection

The State Jewish Chamber Theatre

Chagall's design of the curtain for the State Jewish Chamber Theatre survives only as a tiny watercolour sketch [28]. The artist has chosen a pair of goats' heads, the goat being his favourite symbol at the time for denoting things Jewish (for example, he used it in *The Red Gateway* [1917], Staatsgalerie, Stuttgart). Shortly after the Theatre opened at Bolshoi Chernyshevsky Pereulok on 1 January 1920, the artist insisted that the auditorium be opened for the wider public to see his paintings; this took place in June. When the Theatre moved to larger premises at Malaya Bronnaya Street the murals stayed behind (the auditorium and stage became a studio theatre for the company) and in March-April 1922 the murals were again exhibited *in situ*, this time with work by Nathan Altman and David Shterenberg. By 1925 Chagall's murals had been hung in the new theatre, where they stayed until 1937; they were criticised at this time of Purges and taken down and hidden away for safety. GOSET was formally closed down in 1949 and the seven large panels were accepted by the Tretiakov Gallery in July 1950 from the Commission for the Liquidation of the Moscow Jewish Theatre. The intention was for them to go to Zagorsk to join the Jewish Theatre archive but they remained in store at the Tretiakov. On 8 June 1973 Chagall visited the Tretiakov and the canvases were secretly unrolled – in the presence of KGB agents – and the artist added his signature and dated them. Although Pontus Hulten, then Director of the Centre Pompidou, viewed the murals when he was preparing the 'Paris-Moscou' exhibition (1979) and urged their restoration, it was not until 1987 that the Conservation Department of the Tretiakov Gallery began work on the paintings. The first two to be finished, *Music* and *Dance*, were shown in Tokyo in 1989. Restoration on the other five panels with the co-operation of the Swiss Fondation Pierre Gianadda was complete in time for the entire ensemble to be exhibited at the Fondation Pierre Gianadda at Martigny in Switzerland in January 1991, the sixtieth anniversary of the opening of the Theatre in Moscow in January 1921.

29.
Design for the Curtain of the State Jewish Chamber Theatre
watercolour on buff paper, 14 × 14.9 cm
Private Collection

30.
Love on the Stage
1920
tempera, gouache and opaque white on canvas, 283 × 248 cm
State Tretiakov Gallery, Moscow, inv. G-525

31.
Introduction to the Jewish Theatre
1920
tempera, gouache and opaque white on canvas, 284 × 787 cm
State Tretiakov Gallery, Moscow, inv. G-523

32.
Music
1920
tempera, gouache and opaque white on canvas, 213 × 104 cm
State Tretiakov Gallery, Moscow, inv. G-528

33.
Dance
1920
tempera, gouache and opaque white on canvas, 214 × 108.5 cm
State Tretiakov Gallery, Moscow, inv. G-527

34.
Drama
1920
tempera, gouache and opaque white on canvas, 212.6 × 107.2 cm
State Tretiakov Gallery, Moscow, inv. G-529

35.

Literature

1920

tempera, gouache and opaque white on canvas,
216 × 81.3 cm
State Tretiakov Gallery, Moscow, inv. G-526

36.

The Wedding Feast

1920

tempera, gouache and opaque white on canvas,
64 × 799 cm
State Tretiakov Gallery, Moscow, inv. G-524

Work connected with the Introduction to the Jewish Theatre

Chagall made small studies of the complete composition but he also painted some related ideas including the two shown here, using 'screens' as a way of blocking out part of the action. As an idea for staging this was a radical approach even in Russia, where innovative design already had a long history.

37.

Composition with Circles and Goat

1920

oil on cardboard, 38 × 49.5 cm
Private Collection

38.

Study for Introduction to the Jewish Theatre

1920

watercolour, gouache and oil on cardboard,
35.5 × 17.4 cm
Private Collection

Costume and set designs

Chagall's designs for productions at the State Jewish Chamber Theatre comprised three short plays from stories by Sholem Aleichem, *Mazeltov*, *The Agents* and *It's a Lie*. The plays remained in the repertoire and were seen with Chagall's designs in Europe when the theatre toured in Berlin and Paris. Some originals of the same designs belong to the Bakhrushin Theatre Museum in Moscow, but they have been damaged in a fire. Chagall also made a number of costume and set designs which he sent to directors of other theatres, hoping he would be invited to carry them out. Using published information the designs have been grouped here under the titles of the different plays.

39.

**Costume design for *Mazeltov* by Sholem Aleichem:
Man's Costume**

1920

pencil, gouache and ink on buff paper,
27 × 19.3 cm
Private Collection

40.

Sketch for the stage set of *Mazeltov*

1920

pencil and watercolour on paper, 25.5 × 34.5 cm
Private Collection

41.

The Actor Solomon Mikhoels in *Mazeltov*

1920

pencil and watercolour on buff paper, 36 × 26.3 cm
Private Collection

42.

**Costume design for *Mazeltov*:
Woman with Apron**

1920

ink and watercolour on paper, 28.1 × 12.7 cm
Private Collection

43.

Sketch for the stage set of *The Agents* by Sholem Aleichem

1919–20

pencil, gouache and ink on cream paper,
25.6 × 34.2 cm
Musée national d'art moderne, Centre Georges Pompidou, Paris

44.

**Costume design for *The Agents*:
Man with a Suitcase**

1920

pencil, black ink and gouache on beige paper,
27.4 × 20.3 cm
Musée national d'art moderne, Centre Georges Pompidou, Paris

45.

**Costume design for *The Agents*:
Woman with Child**

1920

pencil and gouache on beige paper, 27.7 × 20.3 cm
Private Collection

46.

Sketch for the stage set of *It's a Lie* by Sholem Aleichem

1920

pencil and gouache on paper, 22.5 × 30 cm
Private Collection

47.

Costume design for the Actor Solomon Mikhoels

1920

pencil and watercolour on paper, 22.5 × 30 cm
Private Collection

48.

**Costume design for *It's a Lie*:
Man with Long Nose**

1920

pencil, black ink and gouache on beige paper,
26 × 18 cm
Private Collection

49.

**Sketch for the stage set of *Comrade Khlestakov* by D. Smolin:
The Little Train (ii)**

1921

pencil, black ink, gouache and watercolour on paper, 28.5 × 34.4 cm
Musée national d'art moderne, Centre Georges Pompidou, Paris

50.

Costume design for Bobchinsky-Dobchinsky in *Comrade Khlestakov*

1921

watercolour and pencil on paper, 27.2 × 19.2 cm
Private Collection

51.

Costume design for Svistunov in *Comrade Khlestakov*

1921
watercolour and pencil on paper, 27.2 × 19.2 cm
Private Collection

52.

Sketch for the stage set of *Comrade Khlestakov*: The Little Goat

1921
pencil, black ink, gouache and watercolour on
paper, 29.2 × 35.6 cm
Musée national d'art moderne, Centre Georges
Pompidou, Paris

53.

Costume design for *The Playboy of the Western World* by J. M. Synge: Young Girl

1921
watercolour (lace imprint), pencil, gouache, black
ink with gold highlights on paper, 32.8 × 25.9 cm
Musée national d'art moderne, Centre Georges
Pompidou, Paris

54.

Costume design for *The Playboy of the Western World*: Kris

1921
black ink, varnish, pencil, gouache and
watercolour on cream paper, 32.8 × 25.9 cm
Musée national d'art moderne, Centre Georges
Pompidou, Paris

55.

Sketch for the stage set of *The Playboy of the Western World*

1921
pencil, black ink, gouache, gold and silver paint
on paper, 40.7 × 51.1 cm
Musée national d'art moderne, Centre Georges
Pompidou, Paris

Black and white drawings

Before Chagall finally left Russia in 1922 he had
explored black and white as a powerful medium
for book and magazine illustrations. His
caricature-like approach and his bold use of black
and white mark him out as an exceptionally
talented draughtsman. He was to develop this side
of his art in 1923 in Berlin where he apprenticed
himself to Hermann Struck, from whom he
learned etching. Chagall used the drawing *Acrobat*
[59] in Paris for an etching in 1924. 100 copies
were printed for Ambroise Vollard's planned third
Album des Peintres-Gravures, which, however, was
never published. Chagall himself had played the
violin as a young man and, from his earliest years,
had been fond of carnival and acrobats, so, with its
theatrical theme, *Acrobat* makes a fitting ending to
'Love and the Stage'.

56.

Abduction

1920
black ink on grey paper, 34 × 47.1 cm
Musée national d'art moderne, Centre Georges
Pompidou, Paris

57.

Man with Marionettes

1916
black ink on brown wrapping paper,
25.7 × 21.4 cm
Musée national d'art moderne, Centre Georges
Pompidou, Paris

58.

With a Bucket

1920
pen and black ink on grey paper, 46.7 × 34 cm
Musée national d'art moderne, Centre Georges
Pompidou, Paris

59.

Acrobat

1918
black ink and red chalk on a leaf of wove paper,
32.4 × 22.4 cm
Musée national d'art moderne, Centre Georges
Pompidou, Paris

The English titles of work by Chagall are taken
from Franz Meyer, *Marc Chagall, Life and Work*,
transl. R. Allen, New York, Abrams, n.d. (1960).
The information on exhibitions is taken from
D. Gordon, *Modern Art Exhibitions 1900–16*, vol.1,
Munich 1974; Christina Burrus, *Marc Chagall:
Chagall en Russie*, Fondation Pierre Gianadda,
Martigny, Switzerland, March–June 1991 and
Marc Chagall, Les années russes, 1907–1922, Musée
d'art moderne de la Ville de Paris, Paris,
April–September 1995. In some cases, notably for
the 'First Free Exhibition' in Petrograd 1919, the
information was not complete in the source.
Information has also been cited from catalogues of
the collections of the Tretiakov Gallery, Moscow
(1984), The Museum of Modern Art, New York
(1977) and the Tate Gallery, London (1981).

Friends of the Royal Academy

Royal Academy Trust

Exhibition Patrons Group

PATRONS

Mrs Denise Adeane
Mr P.F.J. Bennett
Mr David Berman
Mr and Mrs George Bloch
Mrs J. Brice
Mr Jeremy Brown
Mr and Mrs P.H.G. Cadbury
Mrs L. Cantor
Christabella Charitable Trust
Mr and Mrs David Cooke
Mrs Elizabeth Corob
The Hon. and Mrs D. de Laszlo
Mr and Mrs S. Fein
Mr and Mrs Michael Godbee
Lady Gosling
Mr Harold Joels
Mrs G. Jungels-Winkler
Mr and Mrs Marshall J. Langer
Mr and Mrs Andrew D. Law
Dr Abraham Marcus
Mr and Mrs Godfrey Pilkington
Mr and Mrs G.A. Pitt-Rivers
Lady Samuel
Mrs Paula Swift
Mr Robin Symes
Mr John B. Walton
Mrs Edna S. Weiss
Mrs Linda M. Williams
Sir Brian Wolfson

SUPPORTING FRIENDS

Mr Richard B. Allan
Mr and Mrs Peter Allinson
Mr Richard Alston
Mr Ian F.C. Anstruther
Mr John R. Asprey
Lady Attenborough
Mr Paul Baines
Mr James Bartos
Mrs Susan Besser
Mr Peter Boizot MBE
C.T. Bowring (Charities Trust) Ltd
Mrs J.M. Bracegirdle
Mr Cornelius Broere
Lady Brown
Mrs A. Cadbury
Mr and Mrs R. Cadbury
Miss E.M. Cassin
Mr R.A. Cernis
Mr. S. Chapman
Mr W.J. Chapman
Mr and Mrs John Cleese
Mrs R. Cohen
Mrs D.H. Costopoulos
Mr and Mrs C. Cotton
Mrs Sneda H. Dalloul
Mr John Denham
The Marquess of Douro
Mr D.P. Duncan
Mrs K.W. Feesey MSc
Mr Stephen A. Geiger
Mrs R.H. Goddard
Mr Gavin Graham
Lady Grant
Mrs O. Grogan
Mr B.R.H. Hall
Miss Julia Hazandras
Mr Malcolm Herring
Mr R.J. Hoare

Mr Charles Howard
Mr Norman J. Hyams
Mrs Manya Igel
Mr S. Isern-Feliu
Mrs Ilse Jackson
Lady Jacobs
Mr and Mrs S.D. Kahan
Mr and Mrs J. Kessler
Mr D.H. Killick
Mr P.W. Kininmonth
Mrs L. Kosta
Mrs J.H. Lavender
Mr and Mrs David Leathers
Mr Owen Luder
Mrs G.M.S. McIntosh
Ms R. Marek
The Hon. Simon Marks
Mr and Mrs J.B.H. Martin
Mr and Mrs R.C. Martin
Mr and Mrs G. Mathieson
Mr J. Moores
Mrs A. Morgan
Mr David H. Nelson
Mrs E.M. Oppenheim-Sandelson
Mr Brian R. Oury
Mrs J. Pappworth
Mrs M.C.S. Philip
Mrs Anne Phillips
Mr Ralph Picken
Mr G.B. Pincus
Mr W. Plapinger
Mr Benjamin Pritchett-Brown
Mr Clive and Mrs Sylvia Richards
Mr F.P. Robinson
Mr D. Rocklin
Mrs A. Rodman
Mr and Mrs O. Roux
The Hon. Sir Stephen Runciman CH
The Worshipful Company of Saddlers
Dr Susan Saga
Sir Robert and Lady Sainsbury
Mr G. Salmanowitz
Mr Anthony Salz
Mrs Bernice Sandelson
Mrs Bernard L. Schwartz
Mrs Lisa Schwartz
Mr and Mrs Douglas Scott
Mr Mark Shelmerdine
Mr R.J. Simmons CBE
Mr John H.M. Sims
Dr and Mrs M.L. Slotover
Professor and Mrs Philip Stott
Mr and Mrs J.G. Studholme
Mr J.A. Tackaberry
Mr Serge Telandro
Mr G.C.A. Thom
Mrs Andrew Trollope
Mrs Magdalena De Urvoi
Mr and Mrs Ludovic de Walden
Mrs C.H. Walton
Mr Neil Warren
Miss J. Waterous
Mrs Roger Waters
Mrs C. Weldon
Mr Frank S. Wenstrom
Julyan and Tess Wickham
Mrs I. Wolstenholme
Mr W.M. Wood
Mr R.M. Woodhouse
Mr and Mrs F.S. Worms
Ms Karen S. Yamada

BENEFACTORS

H.M. The Queen
Mr and Mrs Russell B. Aitken
American Associates of the Royal
 Academy Trust
Miss B.A. Battersby
Mr Tom Bendhem
Mrs Brenda Benwell-Lejeune
Mr M.J. Bleckwen
Lady Brinton
Mr Keith Bromley
The Brown Foundation Inc.
Mrs Iris Cantor
The Trustees of the Clore Foundation
Sir Harry and Lady Djanogly
Mr R.R. Duff
The Dulverton Trust
Miss Jayne Edwardes
The John Ellerman Foundation
Mr and Mrs Donald R. Findlay
Mr D. Francis Finlay
Mr M.E. Flintoff
Mr Walter Fitch III
Mrs Henry Ford II
The Garfield Weston Foundation
Lord and Lady Gibson
The Jack Goldhill Charitable Trust
The Horace W. Goldsmith Foundation
The Worshipful Company
 of Goldsmiths
Mrs Mary Graves
Mr and Mrs Lewis Grinnan Jr
Mr M.H. Gruselle
Mrs Sue Hammerson
Mr and Mrs Jocelin Harris
Philip and Pauline Harris Charitable
 Trust
The Hayward Foundation
Mrs Henry J. Heinz II, DBE
Mr D.J. Hoare
The J.P. Jacobs Charitable Trust
Mrs Ken Jones
Ms M Jones
Mr and Mrs Donald P. Kahn
Mr James Kemper
Mr and Mrs Kreitman
Mrs Linda Noe Laine
Mr D.E. Laing
Mr Ronald Lay
Sir Hugh Leggatt
Sir Sydney and Lady Lipworth
Mr Jonathan Lyons
Mr and Mrs F. Machin
Mr John Madejski
Mrs T.S. Mallinson
Mr and Mrs John L. Marion
Mrs W. Marks
Mrs Jack C. Massey
Mr Ronald and The Hon. Mrs Rita
 McAulay
Mrs John P. McGrath
The Anthony and Elizabeth Mellows
 Charitable Trust
The Mercers' Company
Lt Col L.S. Michael OBE
The Monument Trust
Lord and Lady Moyne
Mr G.R. Nicholas
Diane A. Nixon
Mrs V. Paravicini
Mr Richard Park

The Peacock Charitable Trust
The P.F. Charitable Trust
The Hon. and Mrs Leon Polsky
The Edith and Ferdinand Porjes
 Charitable Trust
The Radcliffe Trust
The Rayne Foundation
Mrs Alec Reed
Mrs Arthur M. Sackler
Mrs Coral Samuel CBE
Mrs Louisa S. Sarofim
Lady Sharp
The Archie Sherman Charitable Trust
The Very Revd E.F. Shotter
Mr and Mrs James C. Slaughter
Mr Paul Smith CBE
Sir John and Lady Smith
Mr E.B. Spencer
Miss K. Stalnaker
The Starr Foundation
The Steel Charitable Trust
Lady Daphne Straight
Mrs P. Synge
Mr and Mrs Vernon Taylor Jr.
Mr Harry Teacher
The Douglas Turner Charitable Trust
The 29th May 1961 Charitable Trust
Mr and Mrs Henry Vyner
Mrs M. Watson
Mr Anthony Weldon
Mr and Mrs Keith S. Wellin
The Weldon UK Charitable Trust
The Welton Foundation
Mr and Mrs Garry H. Weston
Mr C.J. Weston
The Hon. John C. Whitehead
The Late Mrs John Hay Whitney
Mr and Mrs A. Witkin
The Wolfson Foundation
Mr and Mrs William Wood Prince

The Exhibition Patrons Group was set
up in May 1997 to encourage the
regular and committed support of
individuals who believe in the Royal
Academy's mission to promote the
widest possible understanding and
enjoyment of the visual arts.

The Royal Academy is delighted to
thank the following individuals for
generously supporting the exhibition
programme for 1997/1998 with
donations of £1,000 and more.

PRESIDENT
Garry Weston

CO-CHAIRMAN
Sir Trevor Chinn CVO
The Hon. Mrs Anne Collins
Lady Lever of Manchester

Mrs Vanessa Bernstein
Mr Peter Bowring CBE
Mrs Susan Burns
Mr P.J. Butler
Sir Trevor and Lady Chinn
Sir Harry and Lady Djanogly
Sir Philip Dowson PRA
EFG Private Bank Limited
Dr Gert-Rudolf Flick
The Robert Gavron Charitable Trust
Jacqueline and Jonathan Gestetner
Maggi and David Gordon
Lady Gosling
Mr and Mrs Donald P. Kahn
Mr and Mrs Henry L.R. Kravis
Lady Lever of Manchester
Sir Sydney Lipworth QC and Lady
 Lipworth
Fiona Mactaggart
Sir John Mactaggart
Mrs Jack Maxwell
The Mercer's Company
Mr Paul Meyers
Mr John Nickson
The P.F. Charitable Trust
Mr Michael Palin
Lord and Lady Palumbo
Mr John Raisman CBE
The Rayne Foundation
Mr and Mrs Robert E. Rhea
Mr and Mrs John Ritblat
Mr John A. Roberts FRIBA
The Rubin Foundation
Mr and Mrs Cyril Sainsbury
Mrs Coral Samuel CBE
Mr and Mrs Richard Simmons
The Swan Trust
Sir Anthony and Lady Tennant
Eugene V. and Clare E. Thaw
 Charitable Trust
Mr and Mrs Julian Treger
The 29th May 1961 Charitable Trust
Mr and Mrs Rainer Zietz

and others who wish to remain
anonymous.

Corporate Membership Scheme

Sponsors of past exhibitions

CORPORATE PATRONS

Arthur Andersen
The British Petroleum Company p.l.c.
The Economist Group
Glaxo Wellcome plc
Morgan Stanley International
Rover Group Ltd
The Royal Bank of Scotland

CORPORATE MEMBERS

Alliance & Leicester plc
All Nippon Airways Co. Ltd.
Aon Group Limited
A.T. Kearney Limited
AXA Sun Life plc
Bankers Trust
Bank of America
Banque Nationale de Paris
Barclays PLC
BAT Industries plc
BG plc
BICC plc
BT plc
BUPA
British Aerospace PLC
British Airways plc
British Alcan Aluminium plc
Bunzl plc
Christie's
Cookson Group plc
Coopers & Lybrand
Credit Suisse First Boston Limited
The Daily Telegraph plc
Deutsche Morgan Grenfell
The Diamond Trading Company
Diageo plc
E.D. & F. Man Limited Charitable Trust
Ernst & Young
Gartmore Investment Management plc
Goldman Sachs International Limited
Guardian Royal Exchange plc
Hay Management Consultants Limited
Hillier Parker May & Rowden
ICI
JP Morgan
Korn/Ferry International Limited
Kvaerner Construction Ltd
Land Securities PLC
Lehman Brothers International
Linklaters & Paines
M & G Group P.L.C.
Marks & Spencer
McKinsey & Co.
Mercury Asset Management
Merrill Lynch Europe PLC
Midland Bank plc
Mitchell Madison Group
MoMart plc
Newton Investment Management
 Limited
Old Mutual
Ove Arup Partnership
Pearson plc
The Peninsular and Oriental Steam
 Navigation Company
Pentland Group plc
Price Waterhouse
Provident Financial plc
Reuters
Rio Tinto plc

Robert Fleming & Co. Limited
Rothmans UK Holdings Limited
Salomon Smith Barney
Scottish & Newcastle plc
Sea Containers Ltd.
SmithKline Beecham
The Smith & Williamson Group
Société Générale
Taylor Joynson Garrett
Taylor Woodrow plc
Thames Water PLC
TI Group plc
Trowers & Hamlins
Unilever UK Limited
Yakult UK Ltd

CORPORATE ASSOCIATES

Ashurst Morris Crisp
AT & T (UK) Ltd
Bass PLC
BHP Petroleum Ltd
BMP DDB Limited
BMW (GB) Limited
The BOC Group
Bovis Europe
Charterhouse plc
Chubb Insurance Company of Europe
CJA (Management Recruitment
 Consultants) Limited
Clifford Chance
Coutts & Co
Credit Agricole Indosuez
Credit Lyonnais Laing
The Dai-Ichi Kangyo Bank, Ltd
Dalgleish & Co
De La Rue plc
Durrington Corporation Limited
Enterprise Oil plc
Fina plc
Foreign & Colonial Management Ltd
General Accident plc
The General Electric Company plc
Granada Group PLC
H.J. Heinz Company Limited
John Lewis Partnership plc
Kleinwort Benson Charitable Trust
Lex Service PLC
Macfarlanes
Mars U.K. Limited
Nabarro Nathanson
NEC (UK) Ltd
Nortel Ltd
The Rank Group Plc
Reliance National Insurance Company
 (UK) Ltd
Sainsbury's PLC
Save & Prosper Foundation
Schroders plc
Sedgwick Group plc
Slough Estates plc
Sotheby's
Tate & Lyle Plc
Tomkins PLC
Toyota Motor Corporation
Wilde Sapte

The Council of the Royal Academy thanks sponsors of past exhibitions for their support. Sponsors of major exhibitions during the last ten years have included the following:

ALITALIA
Italian Art in the 20th Century 1989

ALLIED TRUST BANK
Africa: The Art of a Continent 1995*

ANGLO AMERICAN CORPORATION OF SOUTH AFRICA
Africa: The Art of a Continent 1995*

THE BANQUE INDOSUEZ GROUP
Pissarro: The Impressionist and the City 1993

BANQUE INDOSUEZ AND W.I. CARR
Gauguin and The School of Pont-Aven: Prints and Paintings 1989

BBC RADIO ONE
The Pop Art Show 1991

BMW (GB) LIMITED
Georges Rouault: The Early Years, 1903-1920 1993
David Hockney: A Drawing Retrospective 1995*

BRITISH AIRWAYS
Africa: The Art of a Continent 1995

BT
Hokusai 1991

CANTOR FITZGERALD
From Manet to Gauguin: Masterpieces from Swiss Private Collections 1995

THE CAPITAL GROUP COMPANIES
Drawings from the J. Paul Getty Museum 1993

THE CHASE MANHATTAN BANK
Cézanne: the Early Years 1988

CHILSTONE GARDEN ORNAMENTS
The Palladian Revival: Lord Burlington and his House and Garden at Chiswick 1995

CHRISTIE'S
Frederic Leighton 1830-1896 1996
Sensation: Young British Artists from The Saatchi Collection 1997

CLASSIC FM
Goya: Truth and Fantasy, The Small Paintings 1994
The Glory of Venice: Art in the Eighteenth Century 1994

CORPORATION OF LONDON
Living Bridges 1996

THE DAI-ICHI KANGYO BANK LIMITED
222nd Summer Exhibition 1990

THE DAILY TELEGRAPH
American Art in the 20th Century 1993

DE BEERS
Africa: The Art of a Continent 1995

DEUTSCHE MORGAN GRENFELL
Africa: The Art of a Continent 1995

DIAGEO
230th Summer Exhibition 1998

DIGITAL EQUIPMENT CORPORATION
Monet in the '90s: The Series Paintings 1990

THE DRUE HEINZ TRUST
The Palladian Revival: Lord Burlington and his House and Garden at Chiswick 1995
Denys Lasdun 1997

THE DUPONT COMPANY
American Art in the 20th Century 1993

THE ECONOMIST
Inigo Jones Architect 1989

EDWARDIAN HOTELS
The Edwardians and After: Paintings and Sculpture from the Royal Academy's Collection, 1900-1950 1990

ELF
Alfred Sisley 1992

ESSO PETROLEUM COMPANY LTD
220th Summer Exhibition 1988

FIAT
Italian Art in the 20th Century 1989

FINANCIAL TIMES
Inigo Jones Architect 1989

FONDATION ELF
Alfred Sisley 1992

FORD MOTOR COMPANY LIMITED
The Fauve Landscape: Matisse, Derain, Braque and their Circle 1991

FRIENDS OF THE ROYAL ACADEMY
Victorian Fairy Painting 1997

GAMLESTADEN
Royal Treasures of Sweden, 1550-1700 1989

GÉNÉRALE DES EAUX GROUP
Living Bridges 1996

GLAXO WELLCOME PLC
Great Impressionist and other Master Paintings from the Emil G. Bührle Collection, Zurich 1991
The Unknown Modigliani 1994

GOLDMAN SACHS INTERNATIONAL
Alberto Giacometti 1901-1966 1996

THE GUARDIAN
The Unknown Modigliani 1994

GUINNESS PLC (DIAGEO)
Twentieth-Century Modern Masters: The Jacques and Natasha Gelman Collection 1990
223rd Summer Exhibition 1991
224th Summer Exhibition 1992
225th Summer Exhibition 1993
226th Summer Exhibition 1994
227th Summer Exhibition 1995
228th Summer Exhibition 1996
229th Summer Exhibition 1997

GUINNESS PEAT AVIATION
Alexander Calder 1992

HARPERS & QUEEN
Georges Rouault: The Early Years, 1903-1920 1993
Sandra Blow 1994
David Hockney: A Drawing Retrospective 1995*
Roger de Grey 1996

THE HEADLEY TRUST
Denys Lasdun 1997

THE HENRY MOORE FOUNDATION
Henry Moore 1988
Alexander Calder 1992
Africa: The Art of a Continent 1995

THE INDEPENDENT
The Art of Photography 1839-1989 1989
The Pop Art Show 1991
Living Bridges 1996

INDUSTRIAL BANK OF JAPAN, LIMITED
Hokusai 1991

INTERCRAFT DESIGNS LIMITED
Inigo Jones Architect 1989

THE KLEINWORT BENSON GROUP
Inigo Jones Architect 1989

LAND SECURITIES PLC
Denys Lasdun 1997

LOGICA
The Art of Photography, 1839-1989 1989

THE MAIL ON SUNDAY
Royal Academy Summer Season 1992
Royal Academy Summer Season 1993

MARKS & SPENCER
Royal Academy Schools Premiums 1994
Royal Academy Schools Final Year Show 1994*

MARTINI & ROSSI LTD
The Great Age of British Watercolours, 1750-1880 1993

PAUL MELLON KBE
The Great Age of British Watercolours, 1750-1880 1993

MERCURY COMMUNICATIONS
The Pop Art Show 1991

MERRILL LYNCH
American Art in the 20th Century 1993*

MIDLAND BANK PLC
The Art of Photography 1839-1989 1989
RA Outreach Programme 1992-1996
Lessons in Life 1994

MINORCO
Africa: The Art of a Continent 1995

MITSUBISHI ESTATE COMPANY UK LIMITED
Sir Christopher Wren and the Making of St Paul's 1991

NATWEST GROUP
Nicolas Poussin 1594-1665 1995

Sponsors of past exhibitions

THE NIPPON FOUNDATION
Hiroshige: Images of Mist, Rain, Moon and Snow 1997

OLIVETTI
Andrea Mantegna 1992

PARK TOWER REALTY CORPORATION
Sir Christopher Wren and the Making of St Paul's 1991

PETERBOROUGH UNITED FOOTBALL CLUB
Art Treasures of England: The Regional Collections 1997

PREMIERCARE (NATIONAL WESTMINSTER INSURANCE SERVICES)
*Roger de Grey 1996**

REDAB (UK) LTD
Wisdom and Compassion: The Sacred Art of Tibet 1992

REED INTERNATIONAL PLC
Toulouse-Lautrec: The Graphic Works 1988
Sir Christopher Wren and the Making of St Paul's 1991

REPUBLIC NATIONAL BANK OF NEW YORK
Sickert: Paintings 1992

THE ROYAL BANK OF SCOTLAND
Royal Academy Schools Final Year Show 1996
*Braque: The Late Works 1997**
Premiums 1997
Royal Academy Schools Final Year Show 1997
Royal Academy Schools Final Year Show 1998

SALOMON BROTHERS
Henry Moore 1988

THE SARA LEE FOUNDATION
Odilon Redon: Dreams and Visions 1995

SEA CONTAINERS LTD
The Glory of Venice: Art in the Eighteenth Century 1994

SILHOUETTE EYEWEAR
Egon Schiele and His Contemporaries: From the Leopold Collection, Vienna 1990
Wisdom and Compassion: The Sacred Art of Tibet 1992
Sandra Blow 1994
Africa: The Art of a Continent 1995

SOCIÉTÉ GÉNÉRALE, UK
*Gustave Caillebotte: The Unknown Impressionist 1996**

SOCIÉTÉ GÉNÉRALE DE BELGIQUE
Impressionism to Symbolism: The Belgian Avant-Garde 1880-1900 1994

SPERO COMMUNICATIONS
Royal Academy Schools Final Year Show 1992

TEXACO
Selections from the Royal Academy's Private Collection 1991

THAMES WATER PLC
Thames Water Habitable Bridge Competition 1996

THE TIMES
Old Master Paintings from the Thyssen-Bornemisza Collection 1988
Wisdom and Compassion: The Sacred Art of Tibet 1992
Drawings from the J. Paul Getty Museum 1993
Goya: Truth and Fantasy, The Small Paintings 1994
Africa: The Art of a Continent 1995

TIME OUT
Sensation: Young British Artists from The Saatchi Collection 1997

TRACTABEL
Impressionism to Symbolism: The Belgian Avant-Garde 1880-1900 1994

UNILEVER
Frans Hals 1990

UNION MINIÈRE
Impressionism to Symbolism: The Belgian Avant-Garde 1880-1900 1994

VISTECH INTERNATIONAL LTD
Wisdom and Compassion: The Sacred Art of Tibet 1992

YAKULT UK LTD
*RA Outreach Programme 1997-2000**

** Recipients of a Pairing Scheme Award, managed by ABSA*

Other Sponsors

Sponsors of events, publications and other items in the past two years

Diana Armfield RA
Elizabeth Blackadder RA
BT
Bunzl plc
Crossair
Department of Trade and Industry
Sir Harry and Lady Djanogly
Bernard Dunstan RA PPRWA
D.W. Viewboxes Ltd
Esso UK PLC
Gartmore plc
German Foreign Office, Bonn
Hammerson UK Properties plc
Mr and Mrs David Haynes
Mrs Pansy Ho Hui
HSBC Investment Bank PLC
Mr Victor Hwang, Parkview International London plc
IBM UK Limited
Kvaerner
Ladbroke Group plc
Lloyd George Management Ltd
London Borough of Southwark
The Sir Jack Lyons Charitable Trust
Manpower PLC
Marks and Spencer
NatWest Markets
Old Mutual
Peregrine Investment Holdings Ltd
Rothmans UK Holdings Ltd
Salomon Smith Barney
Mrs Basil Samuel
Sea Containers Ltd
Unilever PLC